POSTCARD HISTORY SERIES

Missions of
Southern California

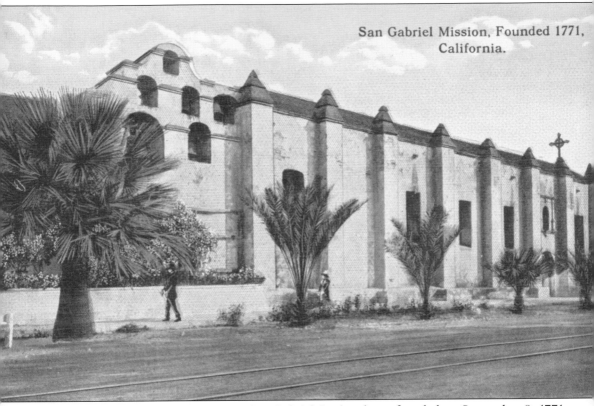

San Gabriel Mission, Founded 1771, California.

ON THE FRONT COVER: Mission San Gabriel Arcángel was founded on September 8, 1771, by Frs. Pedro Cambón and Angel Somera. (Published by the Western Publishing and Novelty Company, Los Angeles, California.)

ON THE BACK COVER: The caption on the reverse of this postcard reads, "Mission San Juan Capistrano is situated upon a group of hills overlooking a beautiful valley extending to the ocean. It is considered the most elaborately decorated and artistically constructed of all the California missions. It is also noted for its fine arched corridor." (Published by the Carlin Postcard Company, Los Angeles, California.)

POSTCARD HISTORY SERIES

Missions of Southern California

James Osborne

ARCADIA
PUBLISHING

Published by Arcadia Publishing
Charleston SC, Chicago IL, Portsmouth NH, San Francisco CA

Printed in the United States of America

Library of Congress Catalog Card Number: 2006939748

For all general information contact Arcadia Publishing at:
Telephone 843-853-2070
Fax 843-853-0044
E-mail sales@arcadiapublishing.com
For customer service and orders:
Toll-Free 1-888-313-2665

Visit us on the Internet at www.arcadiapublishing.com

Dedicated to California's fourth-grade students

CONTENTS

ACKNOWLEDGMENTS

First, I wish to thank my grandmother, the late Helen Buss Thomas, who saved and preserved hundreds of early Southern California postcards that were used for correspondence between herself, her friends, and her family. Her collection provided me, and now others, with a useful glimpse into the past. Second, I wish to thank my mother, Laura Osborne, for the gift of her California missions scrapbook that she produced in 1937 as a fourth-grade assignment at Lawndale's Central School. This scrapbook contained numerous postcards that were (thankfully) easily removed from their glued-down corner holders. And finally, I wish to thank Arcadia Publishing's Jerry Roberts for making this project possible.

INTRODUCTION

Like most California elementary school students, I experienced the assigned project in fourth grade of constructing a homemade model of a California mission. However, unlike a few of my classmates, I thoroughly enjoyed the process of cutting up old shoe boxes and covering them with plaster of paris and then making a roof out of modeling clay. Of course, today's students have the option of purchasing prefabricated kits to build their missions, but California's fourth-grade curriculum still includes instruction about the mission period. And it was my fourth-grade experience, along with my parents' summer vacations that included stops at the missions along Highway 101, that generated my love for the old missions and California history in general.

However, mission history is not viewed by everyone today with as much fondness or appreciation, especially those descendants of the California Native American tribes who were subjugated into what amounted to little more than a form of slavery created by the Spanish Crown. The end result for countless California Native Americans during the 18th century and into the 19th century was the destruction of their preexisting culture and often an early death from diseases introduced into a population with little or no immunity. Still, regardless of what has transpired during the past two centuries since the founding of the first California mission, San Diego de Alcalá, visitors today can enjoy the experience of visiting the beautifully restored missions and capture a glimpse into the past.

Visitors of past decades enjoyed seeing only the remnants, in some cases, of the original adobe-constructed missions. These earlier visits have provided us today with a sample of the scenes those visitors encountered through the practice of sending postcards to friends and family.

The collection presented here is not meant to represent a comprehensive account of the virtually hundreds of Southern California mission postcards published over the years. It is merely a representation of a cross section of the variety of postcards available to collectors today. As well, this compendium can be of value to those who can appreciate the visual documentation of some of California's greatest historical treasures.

The chapters have been arranged for the most part in geographic, rather than chronological, order. They have been situated from south to north, so they are encountered on the page in a sequence that would mirror a traveler's northward journey, beginning at Mission San Diego and heading as far north as Santa Barbara County. The final chapter is essentially a collection of postcards of the smaller missions, or *asistencias*, plus a few additional postcards regarding the most celebrated mission padre, Fr. Junipero Serra. It is the author's hope that the reader will enjoy the variety of images presented here on this photographic journey through some of California's historical treasures.

One

MISSION SAN DIEGO DE ALCALÁ

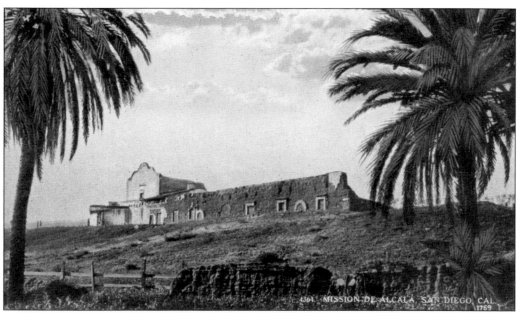

Fr. Junipero Serra founded the first mission in Alta California, San Diego de Alcalá, on July 16, 1769. The site was on Presidio Hill, which overlooked the bay of San Diego and resulted in the first Spanish settlement in Alta California. However, in 1774, the mission was relocated six miles upriver, in large part due to the need for more land to support the growing neophyte population. Ironically, in November 1776, an uprising of approximately 800 Native Americans attacked the mission, killing Fr. Luis Jayme, a blacksmith, and a carpenter, and then burned down the mission. After a period of eight months, the burned-out mission was rebuilt and included a fully developed quadrangle design. (Published by I. L. Eno, San Diego, California.)

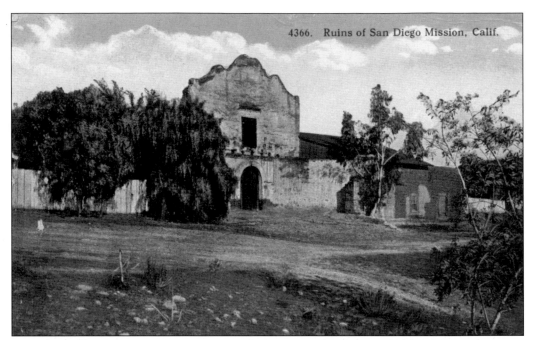

This postcard was postmarked August 31, 1922, and shows the ruined state of the San Diego mission at the close of the 19th century. The mission takes its name from the canonized Franciscan monk San Diego de Alcalá, who lived from 1400 to 1463 and was known for the pious life he led and the "miracles wrought through him." (Published by H. L. Christiance, San Diego, California.)

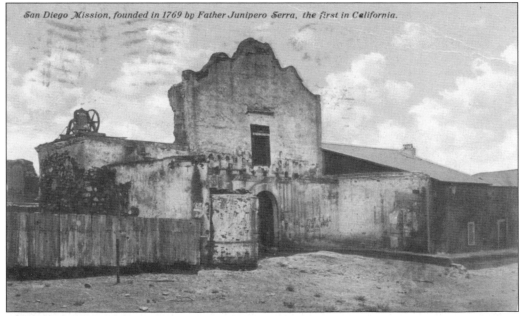

This close-up postcard of the mission San Diego de Alcalá includes a postmark on the back side commemorating the completion of the Panama Canal in 1913. The postcard also describes the mission's main building as "over 150 feet long and walls that are three feet thick." (Published by Eno and Matteson, San Diego, California.)

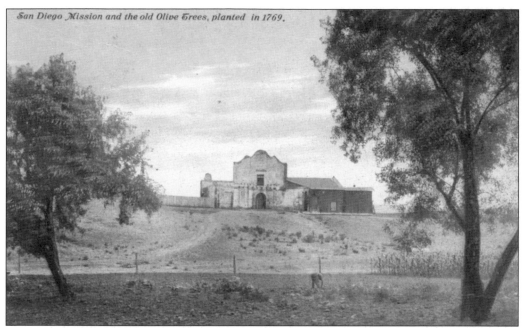

San Diego Mission and the old Olive Trees, planted in 1769.

"San Diego Mission and the old Olive Trees, planted in 1769" is written on the back of this card. This postcard was mailed from Redondo Beach, California, on March 4, 1914. The back of the card also states that the olive trees were planted "a hundred and forty-one years ago," and also claims "they are still bearing fruit." (Published by Eno and Matteson, San Diego, California.)

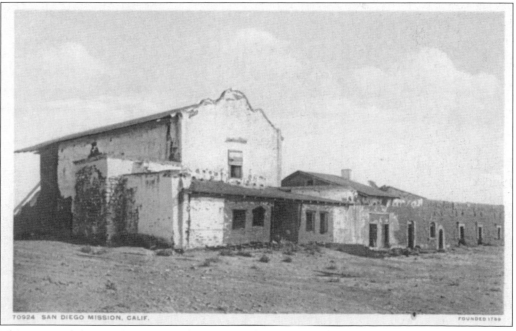

70924 SAN DIEGO MISSION, CALIF. FOUNDED 1769

This postcard depicts the mission about 1892 after the rear of the church had collapsed. Most of the roof tiles had been taken by this time to be "recycled" into the roofs of homes in the Old Town area of San Diego. (Published by the Detroit Publishing Company, Detroit, Michigan.)

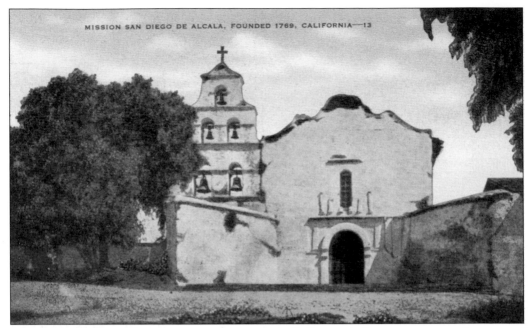

This postcard shows the reconstructed *campanario* (bell tower) that was re-created as part of the mission restoration project in 1931. The church was in active service until the Mexican secularization of 1829. (Published by the Hopkins News Agency, San Diego, California.)

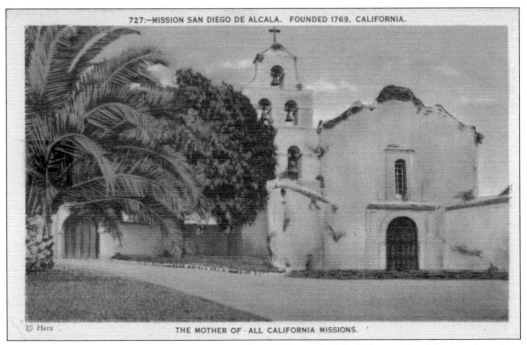

727:—MISSION SAN DIEGO DE ALCALA. FOUNDED 1769, CALIFORNIA.

© Herz THE MOTHER OF ALL CALIFORNIA MISSIONS.

"The Mother of all the California Missions," San Diego de Alcalá is seen here in another view of the campanario. A date palm tree can also be seen at the far left of this image. (Published by Herz Postcards, San Diego, California.)

Here an RPPC or "real-photo postcard" highlights the old bells of the campanario. The bells in the five niches were taken, for a time, from the mission and actually thought forever lost. However, after much searching, they were eventually found and finally rehung. The largest of these bells weighs 1,200 pounds. (Published by Frashers Inc., Pomona, California.)

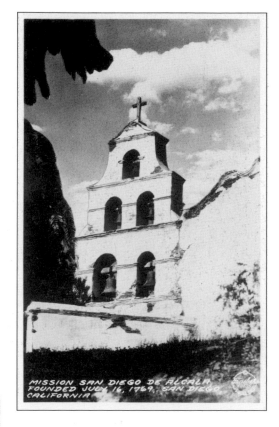

MISSION SAN DIEGO DE ALCALA FOUNDED JULY 16, 1769, SAN DIEGO CALIFORNIA

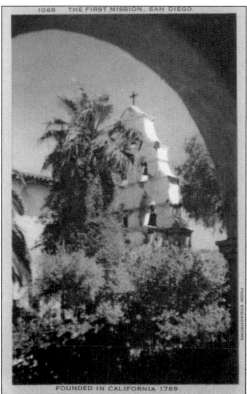

1068 THE FIRST MISSION, SAN DIEGO.

FOUNDED IN CALIFORNIA 1769.

This linen-era postcard shows the mission gardens at the rear of the campanario. The backside reads, in part, "The base of the belfry and the bells are of the original mission, as are the church records written in Padre Serra's own hand." (Published by the Longshow Card Company, Los Angeles, California.)

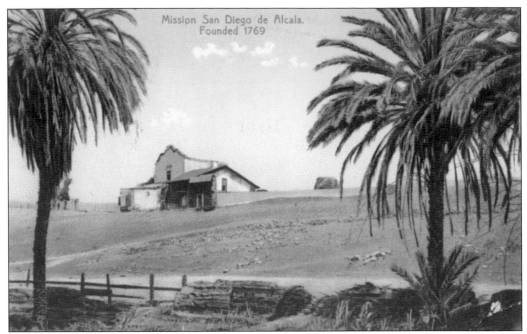

This postcard was printed in Germany and was mailed October 13, 1913, to Aberdeenshire County, Scotland. The message on the reverse side reads, "Another one of the mission cards. Hope you appreciate them all. You will when you see the places themselves." (Published by M. Rieder, Los Angeles, California.)

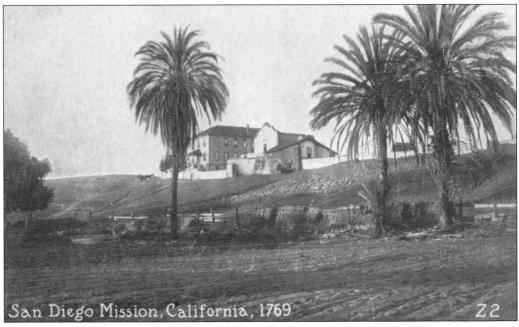

Printed as part of a series, this postcard vividly illustrates the old date palms growing in the foreground. (Published by the Souvenir Publishing Company, San Francisco and Los Angeles, California.)

Two

MISSION SAN LUIS REY DE FRANCIA

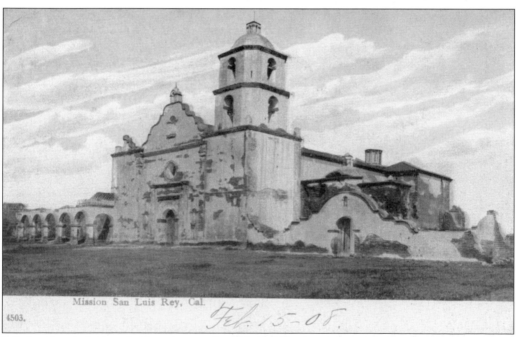

Mission San Luis Rey, Cal.
4503.
Feb. 15-08.

Mission San Luis Rey de Francia was the 18th California mission as well as the ninth and final one to be founded by Fr. Fermin Lasuén on June 13, 1798. It was named for Louis IX, king of France, in honor of his support of the crusades to the Holy Land. During its heyday, San Luis was considered to be "the largest and most populous Indian mission" in all the Americas. The above postcard, mailed February 15, 1908, included the message on its back, which read, "Will be glad to exchange with you. I would like cards with views of anything historic or of wide reputation or of natural scenery." (Published by the Paul C. Koeber Company, New York, New York.)

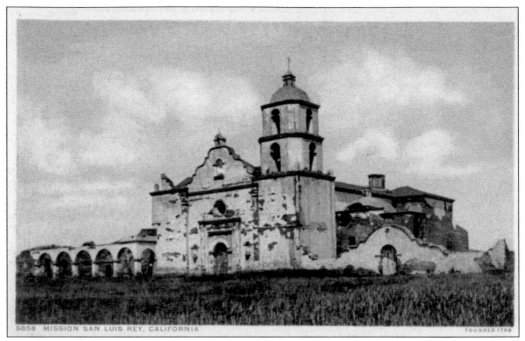

This postcard shows the weathered adobe structure and the mission walls. The construction of San Luis was organized under the direction of Fr. Antonio Peyri, who was the senior padre at the mission for 36 years. (Published by the Detroit Publishing Company, Detroit, Michigan.)

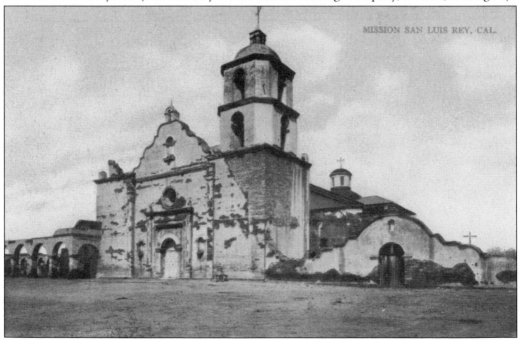

This postcard depicts the mission tower during a further state of decay with the fallen-off plaster exposing the adobe bricks. Some have thought the mission church was incomplete because of the single existing bell tower; however, it is now believed that it was actually part of its original, graceful design. (Published by Woods, Inc., Los Angeles, California.)

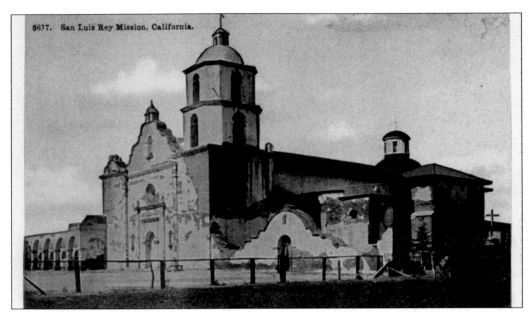

8617. San Luis Rey Mission, California.

During the early life of the mission, construction work was carried on continuously. The local Native Americans provided an abundant workforce totaling over 200 individuals by the end of the first six months of the mission's founding. In fact, within the first month of San Luis Rey's construction, up to 8,000 adobe bricks were formed. (Published by the Pacific Novelty Company, San Francisco and Los Angeles, California.)

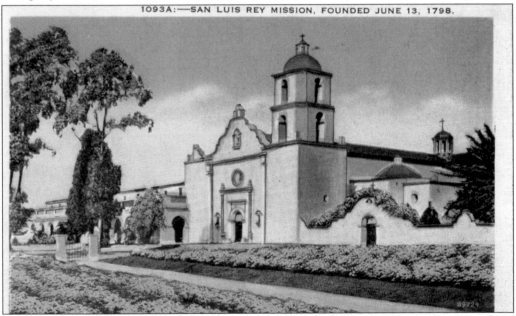

1093A:—SAN LUIS REY MISSION, FOUNDED JUNE 13, 1798.

Seen here is a view of the renovated mission along with its beautifully landscaped grounds. This postcard includes a caption on the back, which reads in part, "The last mission of the 18th century. It was the grandest and most perfect piece of mission architecture in early California, covering almost seven acres under one roof. It is located on the highway between Oceanside and Escondido, some fifty miles from San Diego. A Franciscan college is now located here." (Published by the M. Kashower Company, Los Angeles, California.)

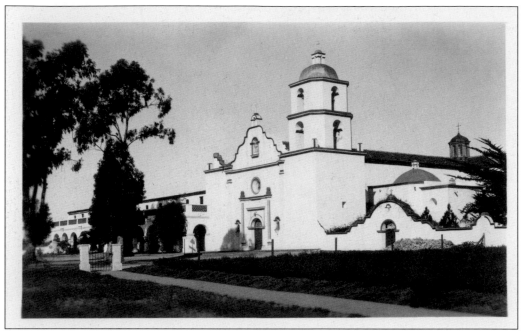

This view is from a very clear RPPC-style postcard. The postcard at the lower portion of the previous page was obviously based on this exact image and then enhanced by an artist. The fresh white plaster on the mission structure creates a striking image when set against the dark-red trim. (Publisher unknown.)

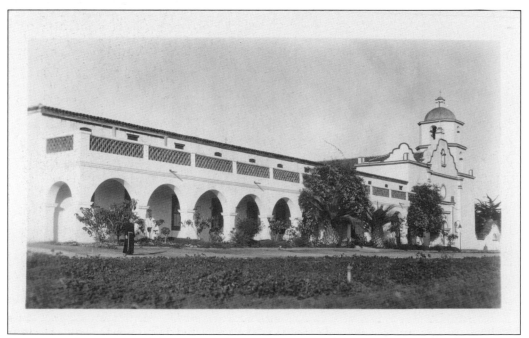

Here is another RPPC of the mission depicting a series of arches, seen at left. Behind these arches today exists the mission's museum and gift shop. A lone padre can be seen standing at far left in this image. (Publisher unknown.)

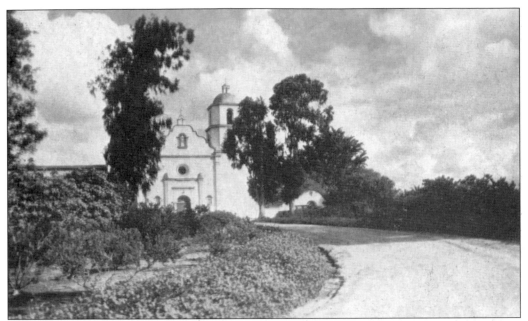

This postcard shows the dirt road that leads up to the mission's entrance. Part of the construction of this mission in 1798 was accomplished through the use of soldiers from the San Diego presidio. They were expected to work at the site "without murmuring," which could be interpreted today as "without complaining." The back of the postcard claims the image to be reproduced by "Spectratone" from a kodachrome. (Published by Wesco Color Card.)

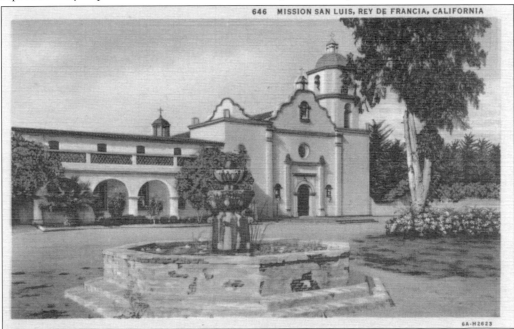

This linen–era postcard of San Luis Rey shows a close–up view of the mission fountain. The back of the card reads, in part, "The mission is situated on an eminence that commands a splendid view of the surrounding country, 85 miles from Los Angeles and 45 miles from San Diego." (Published by the Western Publishing and Novelty Company, Los Angeles, California.)

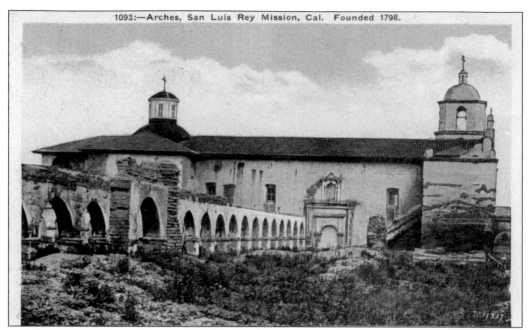

1093:—Arches, San Luis Rey Mission, Cal. Founded 1798.

This postcard clearly illustrates the mission arches. The design of the mission church was based upon a cruciform, and the only other mission church that utilized this same design was Mission San Juan Capistrano. The dome seen here at left was placed at the crossing. It included the unusual octagonal lantern that is not found in any other mission. (Published by the M. Kashower Company, Los Angeles, California.)

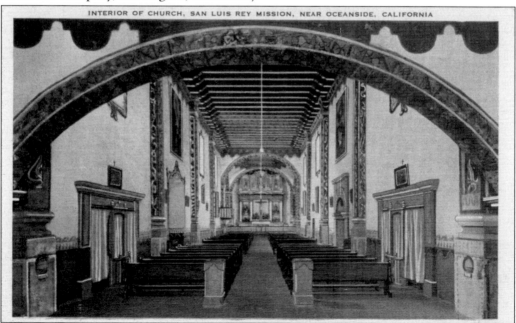

INTERIOR OF CHURCH, SAN LUIS REY MISSION, NEAR OCEANSIDE, CALIFORNIA

Depicted in this postcard is the interior of the church. The caption on the reverse of the card reads, "Mission San Luis Rey de Francia was the largest and most perfect piece of mission architecture produced in early California. It comprised almost seven acres under one roof." (Published by Mission Drug Company, Oceanside, California.)

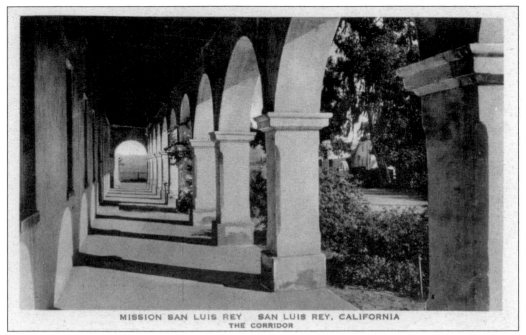

MISSION SAN LUIS REY SAN LUIS REY, CALIFORNIA
THE CORRIDOR

This postcard illustrates the view down the long corridor. (Published by the Albertype Company, Brooklyn, New York.)

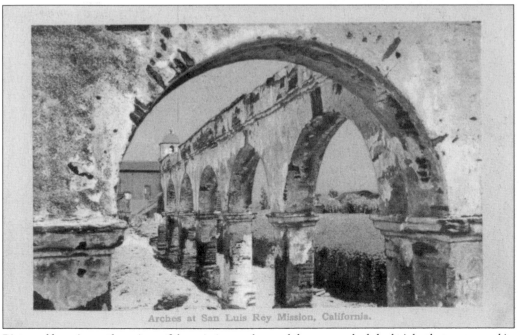

Arches at San Luis Rey Mission, California.

Pictured here is another view of the mission arches and the exposed adobe bricks that were used in constructing them. (Published by the Newman Postcard Company, Los Angeles, California.)

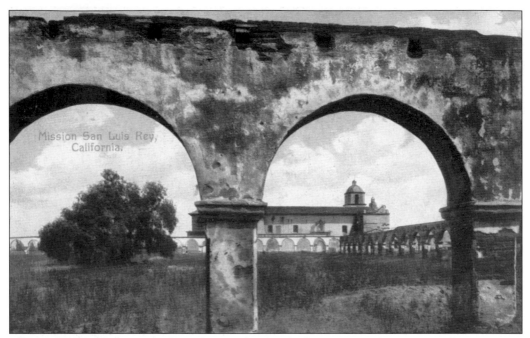

This postcard of San Luis Rey's arches was postmarked in Los Angeles on December 18, 1908. The short note on the back reads, "Best wishes for a Merry Christmas and a Happy New Year, Aunt Kate." (Published by the Newman Postcard Company, Los Angeles, California.)

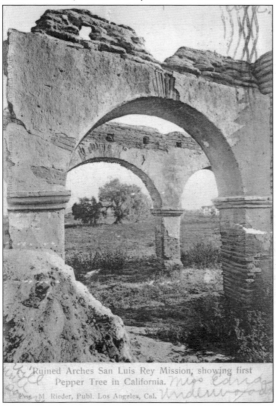

Postmarked August 29, 1905, this postcard illustrates the ruined arches and the very first pepper tree that was planted in California. The California pepper tree, *Schinus molle*, is actually not a native of California but of Peru. It is nevertheless considered the characteristic tree of the California mission garden and is also commonly seen as a street tree throughout Southern California. (Published by M. Rieder, Los Angeles, California.)

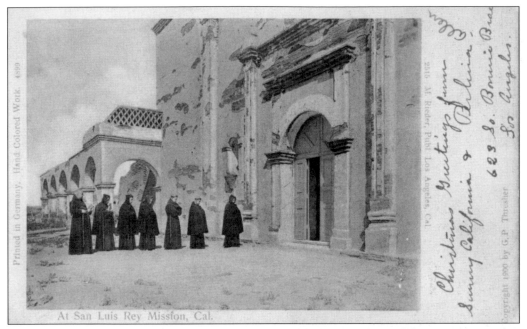

This very early postcard of the mission was postmarked in Los Angeles, California, on December 14, 1904. Printed in Germany, it shows the mission padres entering the church building single file. (Published by M. Rieder, Los Angeles, California.)

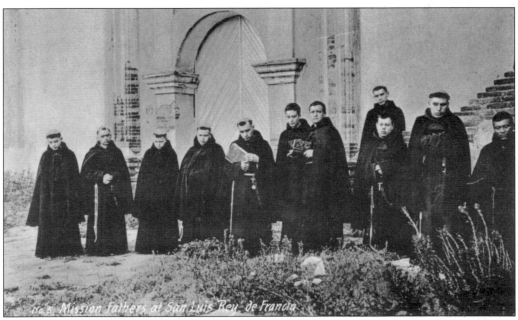

Here is a close-up view of the mission fathers of San Luis Rey de Francia standing before the side entrance to the church. (Published by Vroman's.)

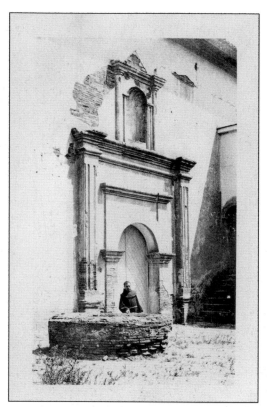

In another RPPC of the mission, the side entrance of the church with a lone priest in front is depicted. (Publisher unknown.)

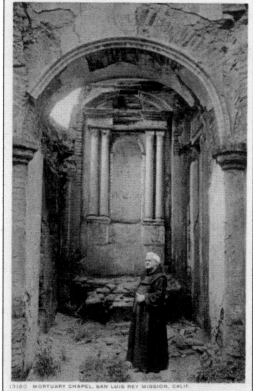

This postcard provides a view of the mortuary chapel. The chapel can be entered from the nave of the church and, as seen here, includes the recess where the church's altar once existed. At one time, there was also a stairway at the back of the altar that led to a balcony overlooking the chapel. It was here that the relatives of the deceased family member could guard the body the night before the funeral service. (Published by the Detroit Publishing Company, Detroit, Michigan.)

Three

MISSION
SAN JUAN CAPISTRANO

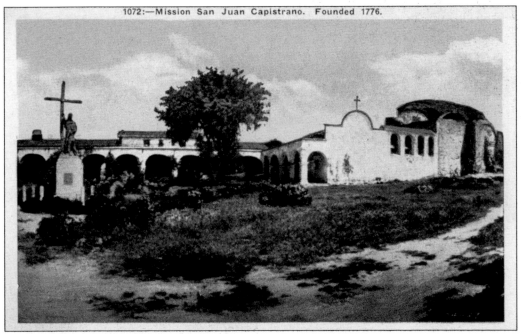

1072:—Mission San Juan Capistrano. Founded 1776.

Founded by Fr. Junipero Serra on November 1, 1776, Mission San Juan Capistrano was named for St. John of Capistrano, Italy, who was a 14th-century inquisitor and theologian. However, the mission was actually founded a year earlier when Fr. Fermin Lasuén erected a cross at the site on October 30, 1775. But the construction was halted when news reached Lasuén about a recent Native American attack at Mission San Diego. Father Lasuén then ordered the bells to be buried and returned with his party to San Diego. One year later, Father Serra returned to the site, unearthed the bells, and held the first service. By the end of the following year, a small chapel had been completed. Today this chapel is considered the oldest church in California and is known as "Father Serra's Church." (Published by the M. Kashower Company, Los Angeles, California.)

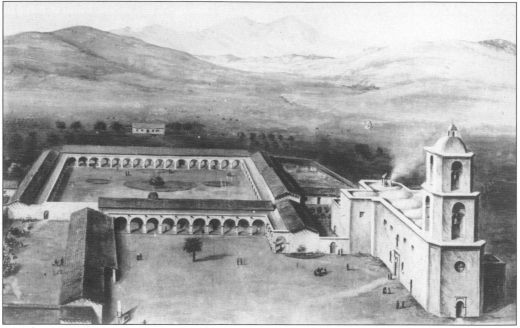

This postcard shows a drawing of an aerial view of how the mission may have once looked; a drawing or painting of the completed mission has never been found. Sadly, in December 1812, a large earthquake struck just after the morning Mass and collapsed the Great Stone Church building seen at right in this image. The tragedy resulted in the deaths of 40 members of the praying congregation. (Publisher unknown.)

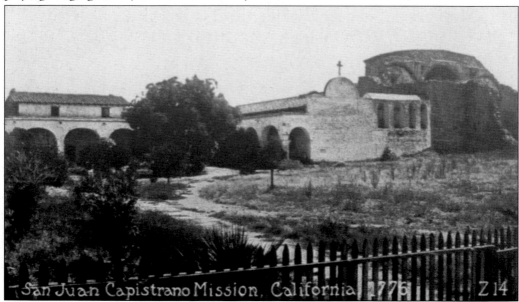

San Juan Capistrano Mission, California 1776 Z14

Here a portion of the church ruins can be seen at right. The Great Stone Church was begun in 1796 using the Native American labor force. The stone for the church was quarried from a site six miles northeast of the mission and was built under the supervision of a stonemason who was brought up north from Mexico. (Published by the Souvenir Publishing Company, San Francisco and Los Angeles, California.)

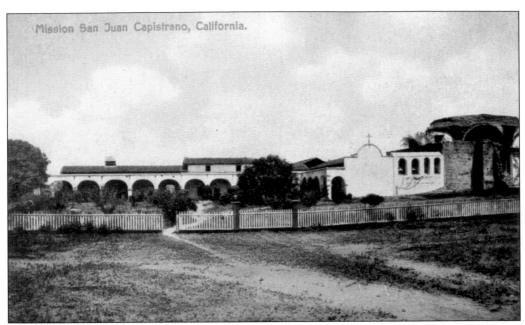

Mission San Juan Capistrano, California.

This postcard shows the old wooden fence that once surrounded the mission's entrance. The inscription on the back of the postcard reads, "Situated upon a group of hills overlooking a beautiful valley extending to the ocean, San Juan Capistrano is considered the most elaborately decorated and artistically constructed of the California Missions." (Published by the Newman Postcard Company, Los Angeles, California.)

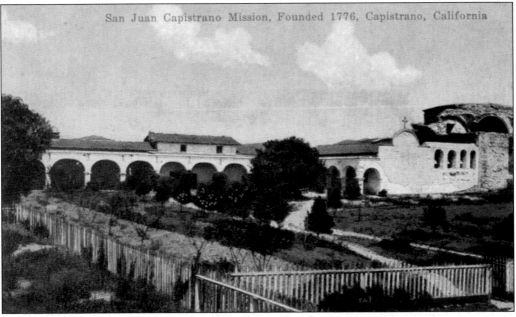

San Juan Capistrano Mission, Founded 1776, Capistrano, California

Here is a close-up view of the old fence surrounding the mission garden. This postcard was postmarked in San Juan Capistrano on December 16, 1920, and was sent to Hudson, Michigan. Part of the handwritten message on the back reads, "Dear Lela, Don't think we have forgotten you folks because we haven't. We like it here fine. Theresa." (Published by the M. Kashower Company, Los Angeles, California.)

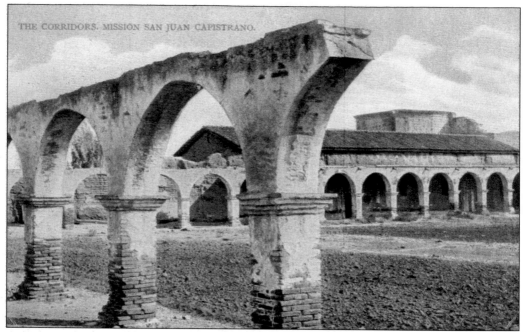

Seen here is a close-up view of the ruins of the old mission corridors. The exposed adobe bricks can be clearly seen below the old arches. (Published by L. R. Stevens, Los Angeles, California.)

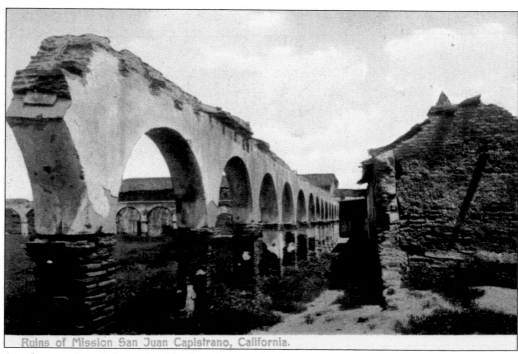

Ruins of Mission San Juan Capistrano, California.

Another angle of the ruined arches is seen in this postcard. During its prime, San Juan Capistrano was one of the most prosperous of the missions. This image, taken during its ruined state, illustrates the stark contrast between the mission's glorious past and the crumbling adobe. (Published by the Newman Postcard Company, Los Angeles, California.)

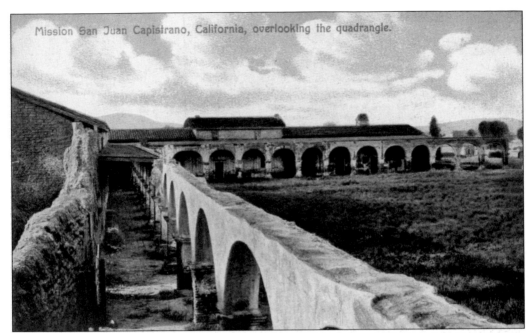

This view, taken from atop the arches, overlooks the quadrangle, which nearly equals an acre in size. Within this area were at one time various shops for producing clothing, candles, and soap. Other buildings were used to store grains and supplies. (Published by the Newman Postcard Company, Los Angeles, California.)

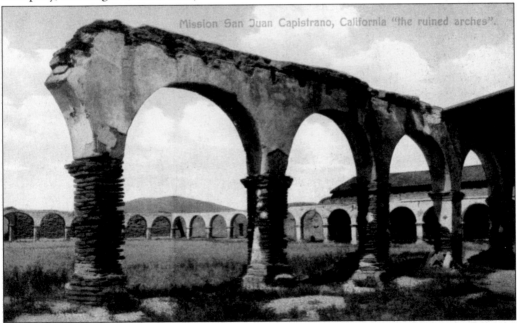

An attempt was made to restore San Juan Capistrano during the 1860s, but it actually did more harm than good. By the 1890s, another attempt was conducted by the Landmarks Club that did manage to preserve Father Serra's Church. And another more extensive restoration undertaken by Fr. St. John O'Sullivan actually did manage to repair several buildings during the 1920s. (Published by the Newman Postcard Company, Los Angeles, California.)

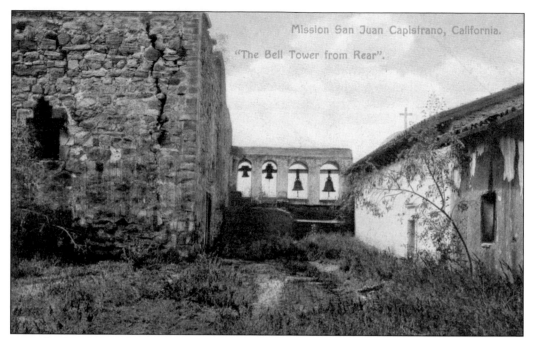

Here the four bells of the campanario are seen from the rear of the structure. These bells, along with the mission's famous swallows, have been celebrated in writings and in song. During the 1812 earthquake, these bells, along with the tower, fell and were rehung later as seen here. (Published by the Newman Postcard Company, Los Angeles, California.)

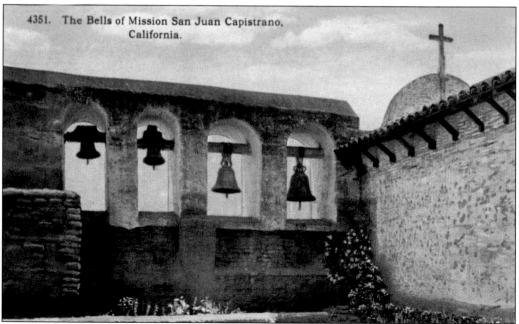

This close-up view of the bells clearly shows their contrasting sizes. The largest bell, seen at right, is cherished due to the inscription it carries—the names of the padres who were at the mission when the bell was originally cast in 1796. The smaller bells were cast in 1804. (Published by I. L. Eno, San Diego, California.)

30

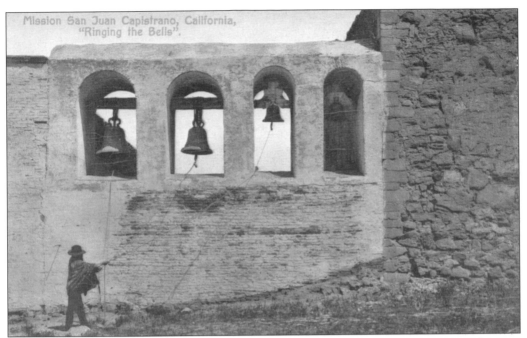

At left, the bell ringer, Don Ramon Arguello II, pulls the ropes attached to the clappers. Over the years, there have been various legends of the bells mysteriously ringing themselves at moments of sad or happy love affairs involving parishioners. (Published by the Newman Postcard Company, Los Angeles, California.)

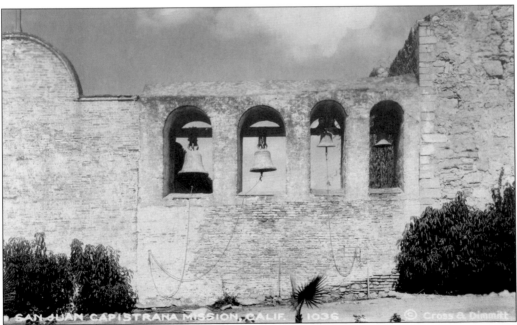

This RPPC of the mission bells was postmarked in Los Angeles on May 5, 1927, and sent to Columbus, Ohio. Part of the inscription on the back reads, "Dear Mother, Just a card as I am going to bed tonight early. We are taking the whole school out for a picnic to a park tomorrow. A big day is ahead. With love, Helen." (Published by Cross and Dimmitt.)

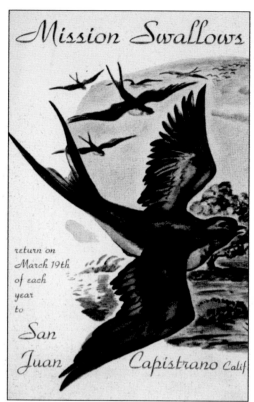

Mission Swallows

return on
March 19th
of each
year
to

San
Juan *Capistrano Calif*

Perhaps the most famous inhabitants of any of California's missions have been the swallows of Capistrano. Praised in song and verse, these cliff swallows return to the mission each year on St. Joseph's Day, March 19. The birds remain through the summer, feeding on flying insects and building their mud nests along the upper arches of the mission, and then depart on St. John's Day, October 23, for the 2,000-mile journey to their wintering grounds in South America. (Published by James Di Maio, San Juan Capistrano, California.)

The drawing seen in this postcard illustrates the mud nests of the cliff swallows situated just below the eaves of the roof. The nests are constructed by the birds using a mixture of saliva and mud and then placing a lining of grass and feathers inside. (Published by the Angeleno Photo Service, Los Angeles, California.)

Pictured here is the Sacred Garden in the foreground with the mission bells of the campanario just beyond. By this time, ivy had covered the inner wall of the campanario and the exterior wall of the Great Stone Church, seen here at left. (Published by the Angeleno Photo Service, Los Angeles, California.)

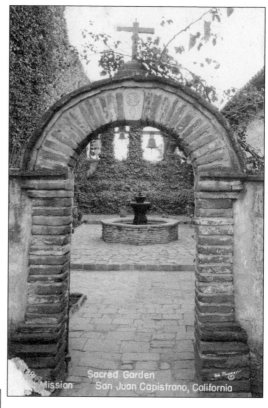

Mission Sacred Garden
 San Juan Capistrano, California

THE CHAPEL 95166

The caption on the back of this postcard reads, "This Chapel has been in use only since 1890. It was originally the living rooms of the fathers in charge. Many of the objects in the present church were used in the Great Stone Church before it fell in the earthquake of 1812." (Published by Artchrome.)

33

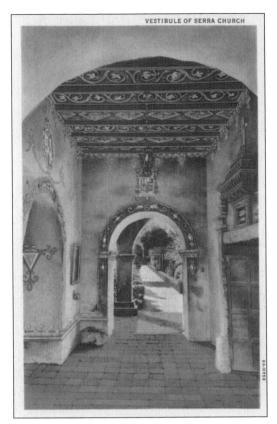

VESTIBULE OF SERRA CHURCH

Here is the vestibule of the Father Serra Church while looking west into the inner patio and the Spanish Garden. Some of the designs that were painted on the ceiling when it was restored in 1922 can be seen in this postcard. (Published by the Western Publishing and Novelty Company, Los Angeles, California.)

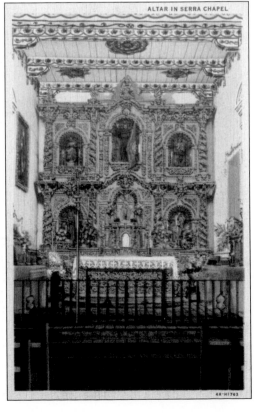

ALTAR IN SERRA CHAPEL

Seen here is the beautiful reredos brought to California from Barcelona, Spain, in 1906, originally planned for the new cathedral in Los Angeles. It was kept in storage until given to the chapel for its 1922 restoration under the direction of Fr. St. John O'Sullivan. This gilt-work altarpiece is believed to be at least 300 years old and is a fitting addition to what is thought to be the oldest religious building in the state of California. (Published by the Western Publishing and Novelty Company, Los Angeles, California.)

34

This postcard is an illustrated version of the previously seen RPPC image of the Sacred Garden and the campanario that was built in 1813 to accommodate the mission bells after the great earthquake of 1812. (Published by C. T. Art–Colortone.)

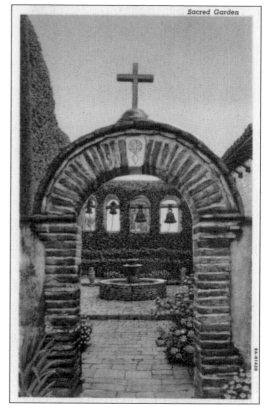

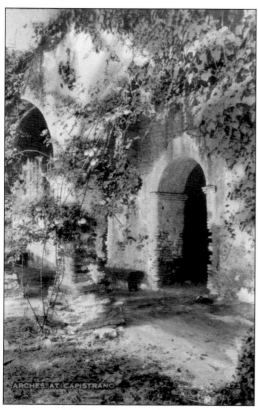

This postcard shows some of the mission arches overgrown with ivy and a climbing rose at left. (Published by the Martin Ross Company, Pasadena, California.)

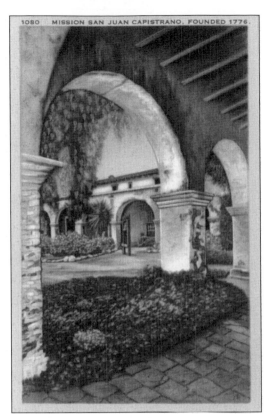

1080　MISSION SAN JUAN CAPISTRANO. FOUNDED 1776.

The caption on the reverse of this postcard reads, "The beautifully arched corridors of the patio of San Juan Capistrano are part of the scene of the famous modern 'Miracle of the Swallows.' On October 23rd they fly out to sea and return the following March 19th to the utter bewilderment of scientists." (Published by the Longshaw Card Company, Los Angeles, California.)

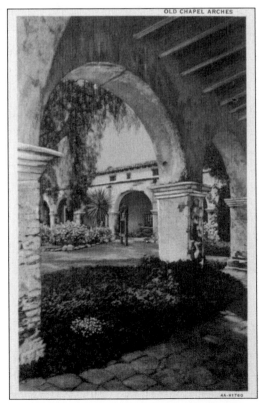

OLD CHAPEL ARCHES

Here is a postcard with an image that is identical to the previous one. However, this caption reads, "The Old Chapel Arches in the front mission garden looking towards the padres' quarters. The Chapel has been in use since 1890. It was originally the living rooms of the fathers in charge." (Published by the Western Novelty Company, Los Angeles, California.)

This postcard illustrates a view of the east corridor and also shows the rear of the restored Serra Chapel, which was reconstructed under the supervision of Father O'Sullivan. (Published by the Western Novelty Company, Los Angeles, California.)

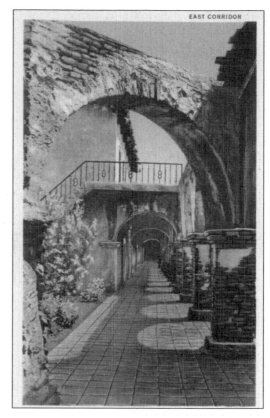

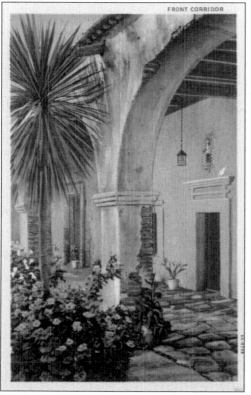

The view here is of the front corridor. At left can be seen the entrance to the Spanish Patio, and at right is seen the doorway leading to the old quarters formerly used by the padres of the mission. (Published by the Western Novelty Company, Los Angeles, California.)

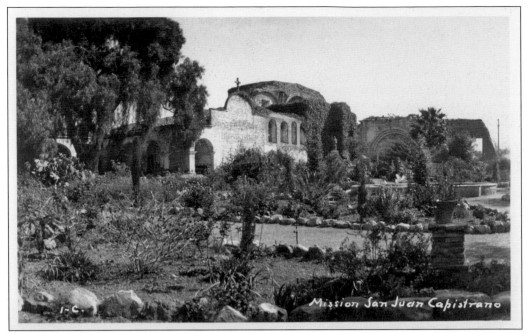

Here is an RPPC showing the mission's gardens along with the back of the campanario. The ruins of the Great Stone Church are seen in the background at right. (Publisher unknown.)

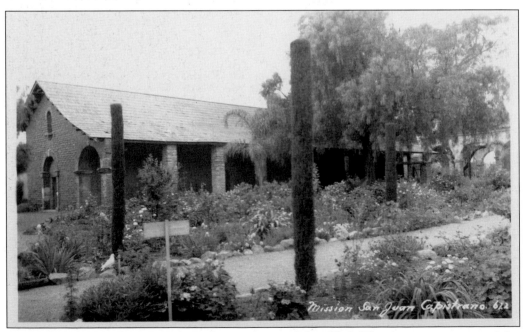

This RPPC shows the mission's gardens and one of the old California pepper trees at right, and also columnar-shaped Italian cypress trees trimmed like poles are seen in the foreground. (Publisher unknown.)

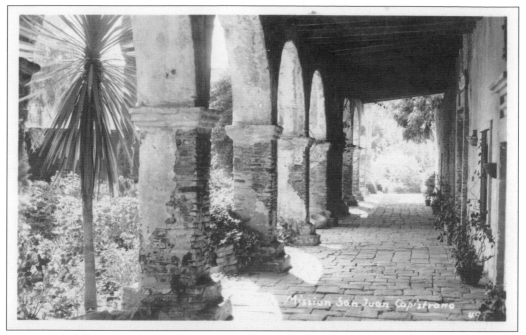

Seen in this RPPC is an interior view of the partially restored arches. At left is a stately growing yucca tree. (Publisher unknown.)

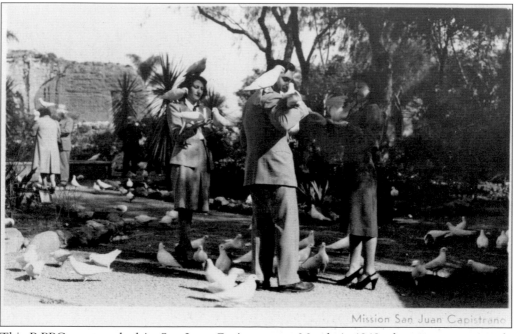

This RPPC, postmarked in San Juan Capistrano on March 1, 1948, shows a young couple feeding the mission's white doves. The message on the back reads, "We visited this place today and it is beautiful. We have seen many interesting places and have enjoyed our trip." (Publisher unknown.)

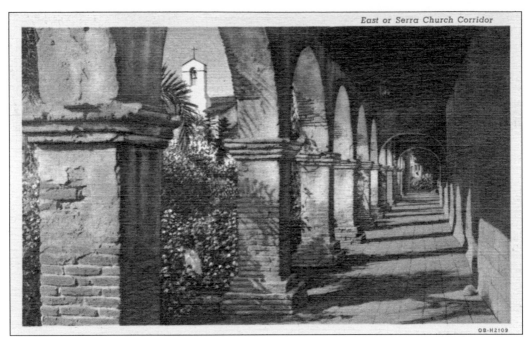

East or Serra Church Corridor

OB-H2109

Viewed here is the east, or Father Serra Church, corridor. The message written on the reverse of this postcard dated May 15, 1958, reads, "Dear Rena, This is the most beautiful place. We are having a wonderful time. Love, Margaret." (Published by the Western Publishing and Novelty Company, Los Angeles, California.)

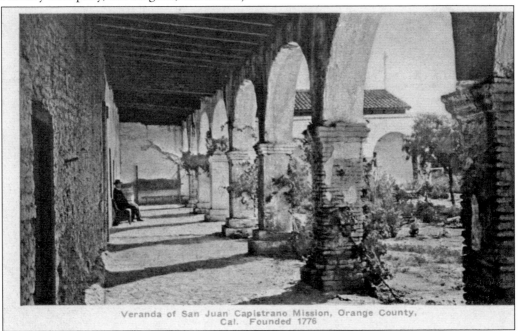

Veranda of San Juan Capistrano Mission, Orange County, Cal. Founded 1776

This postcard depicts the "Veranda of San Juan Capistrano Mission, Orange County, Cal. Founded 1776." A lone visitor is seen at left looking out across the quadrangle. Despite earthquakes and decay, Capistrano is still considered striking in its design. (Published in Los Angeles, California.)

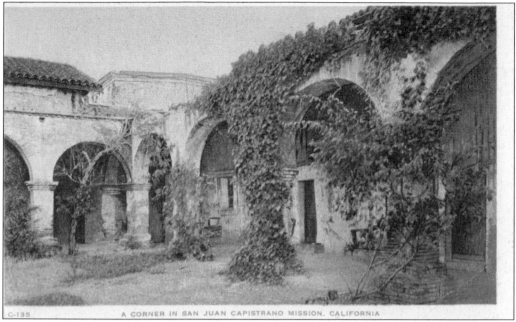

A CORNER IN SAN JUAN CAPISTRANO MISSION, CALIFORNIA

This corner of the mission shows the ivy overtaking the mission arches. Over time, such landscape plants can do more harm than good to the aged adobe structures, and their removal is often required. The grounds of Capistrano today are much better cared for than they were at the time of this postcard's printing during the 1920s. (Published by the H. H. T. Company.)

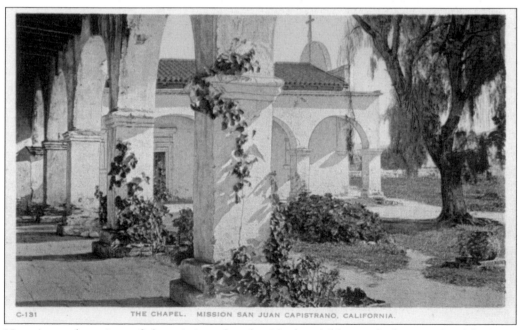

THE CHAPEL, MISSION SAN JUAN CAPISTRANO, CALIFORNIA.

Here is another view of the mission chapel with the visible attached cross. At right is an attractive example of a California pepper tree. Unfortunately, as these trees age, large limbs can sometimes fail and cause damage to structures. Still, the tree's gift of shade and beauty cannot be overestimated. (Published by the H. H. T. Company.)

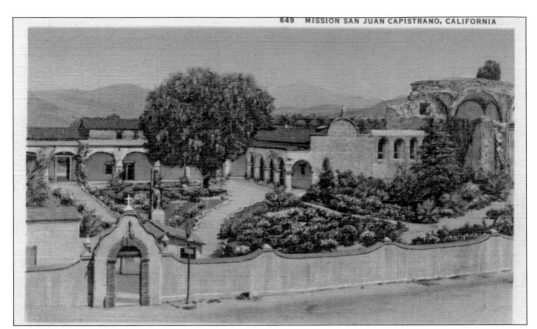

Pictured here is a newer version of the entrance to the mission courtyard. However, San Juan Capistrano was still a small town at the time of this postcard's printing during the 1940s. Just to the right of the entrance can be seen one of the bells placed along the historic El Camino Real, or "The Royal Road," which began as a path connecting the missions. It later evolved into U.S. Highway 101. (Published by the Western Publishing and Novelty Company, Los Angeles, California.)

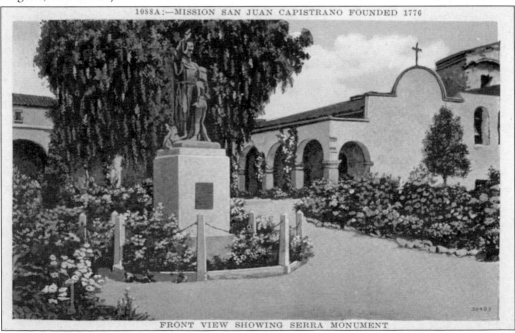

Depicted in this postcard is the monument to Father Serra that was dedicated on November 24, 1914, to commemorate the 201st anniversary of his birth. (Published by the M. Kashower Company, Los Angeles, California.)

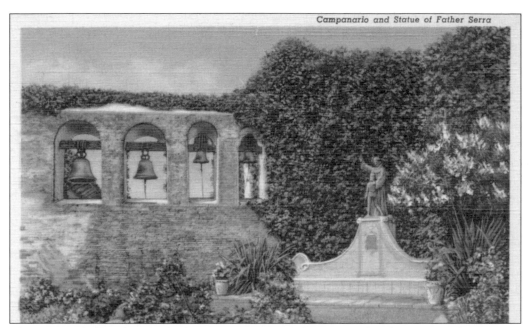

This postcard illustrates both the campanario and the statue of Father Serra. The message written on the reverse of this postcard dated February 5, 1951, reads, "Dear Dad, We are at this mission while writing this card. It is a beautiful place. Weather here is wonderful." (Published by C. T. Art-Colortone.)

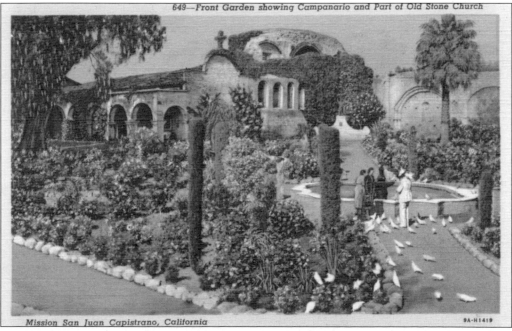

649—Front Garden showing Campanario and Part of Old Stone Church

Mission San Juan Capistrano, California

Pictured here are the front garden and the campanario (behind it) as well as part of the ruins of the Great Stone Church. Note the group of visitors at right feeding the flock of white doves. This postcard was postmarked in Redlands, California, on March 16, 1949, and was sent to the state hospital in Patton, California. (Published by the Western Publishing and Novelty Company, Los Angeles, California.)

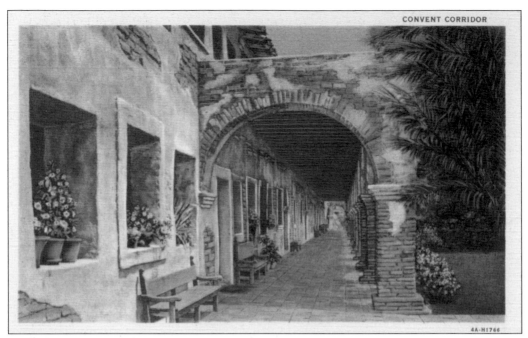

The "Convent Corridor" is seen in this image. The caption on the reverse reads, "This building, formerly used as a warehouse where crops, hides and tallow's were stored, was restored in 1924 by the Tr. Rev. Msgr. St. John O'Sullivan and is now in use as a school for the children of the mission district." (Published by the Western Publishing and Novelty Company, Los Angeles, California.)

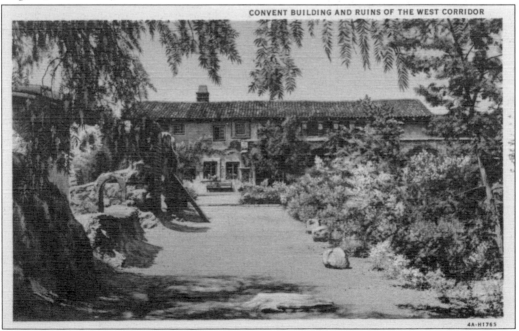

The convent buildings and the ruins of the west corridor are viewed in this postcard. At left are the ruins of the workshops where Native Americans were taught their trades. (Published by C. T. Photo Colorit.)

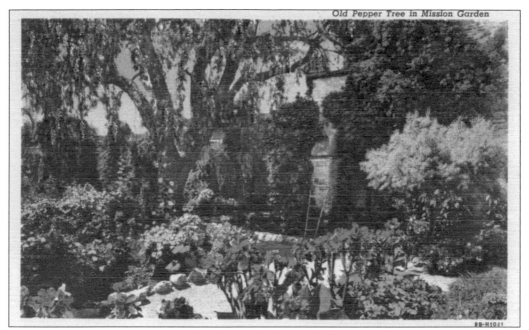

One of the old California pepper trees is featured in this linen-era postcard. The caption on the reverse reads, "The large pepper tree that graces the front of the mission is typical of early California, and banked with gorgeous flowers on all sides, adds to the charm of the old cloisters." (Published by C. T. Photo Colorit.)

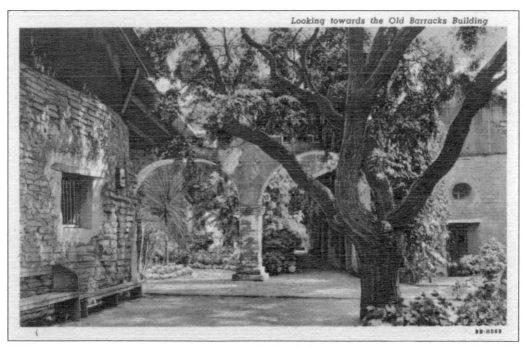

This postcards caption reads, "Looking towards the old barracks, the ivy covered corridors, the profusion of flowers and shaded walks thru the gardens, add to the charms and beauty of this historical spot." (Published by C. T. Photo Colorit.)

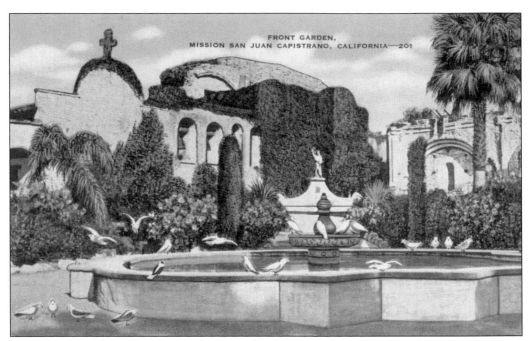

Another view of the front garden with the white doves enjoying the central fountain is seen in this old postcard. (Published by the Hopkins News Agency, San Diego, California.)

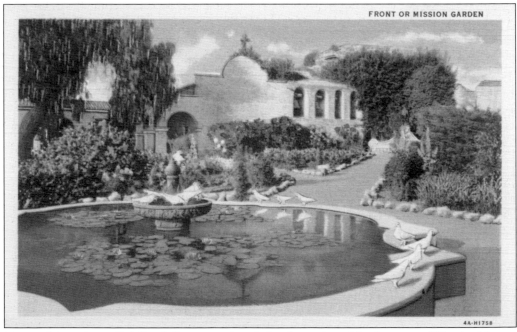

Pictured here is a slightly different angle of the fountain with the water lilies in bloom. (Published by the Western Publishing and Novelty Company, Los Angeles, California.)

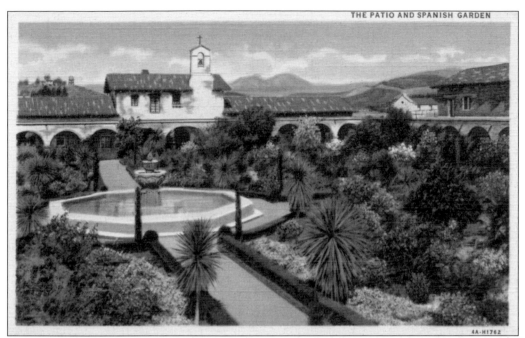

Here is an overview of the Patio, or Spanish Garden. In the center of the Patio is the Fountain of the Four Evangelists, and just beyond is the bell tower of the padre's rectory. At far right is a portion of the Serra Chapel. Note the yuccas thriving in the foreground. (Published by the Western Publishing and Novelty Company, Los Angeles, California.)

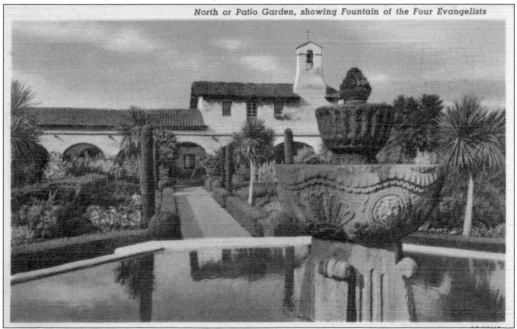

North or Patio Garden, showing Fountain of the Four Evangelists

Seen here is a close-up view of the Fountain of the Four Evangelists. This postcard was postmarked July 7, 1944, and the message on the reverse reads, "Dear Gals, This is the mission to where the swallows return each March. It's a beautiful place." (Published by the Western Publishing and Novelty Company, Los Angeles, California.)

47

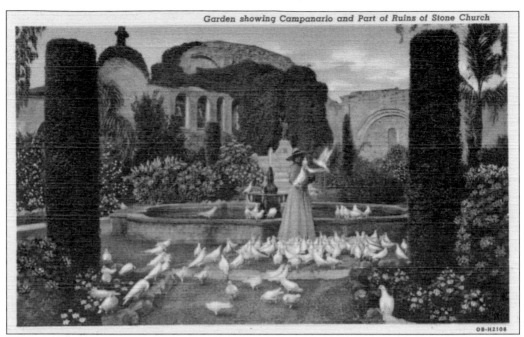

Here a young woman feeds the white doves beside the fountain of the front garden. The ruins of the Great Stone Church are seen in the background. (Published by C. T. Photo Colorit.)

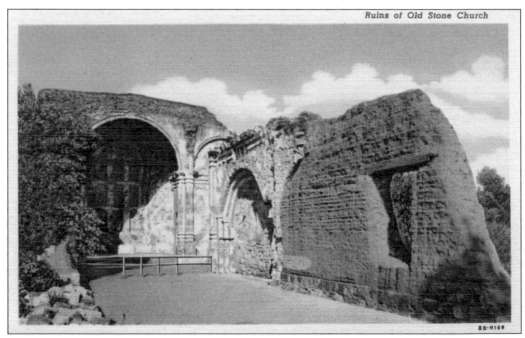

This close-up view shows the ruins of old Great Stone Church. When it was completed in 1806, it was considered the most magnificent of all the mission churches in California. (Published by C. T. Colorit.)

Four

MISSION SAN GABRIEL ARCÁNGEL

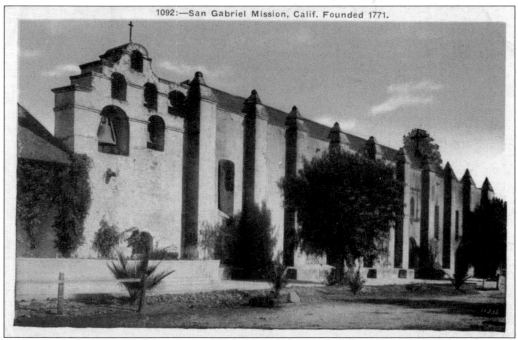

1092:—San Gabriel Mission, Calif. Founded 1771.

Fr. Pedro Cambón and Fr. Angel Somera founded San Gabriel Arcángel on September 8, 1771. In chronological order, it was the fourth mission and is noted for its unique architectural style. The capped buttresses along the exterior of the church are rooted in the Moorish style found in the Cathedral of Cordova, Spain. It was at Cordova that Fr. Antonia Cruzado, who was in charge of the construction, was born. Father Serra selected the original site for the mission; however, Father Lasuén selected a new site in 1775 where construction of the present church began in 1791 and was completed in 1805. Unfortunately, the great earthquake of 1812 damaged the structure, but repairs were completed by 1828. (Published by the M. Kashower Company, Los Angeles, California.)

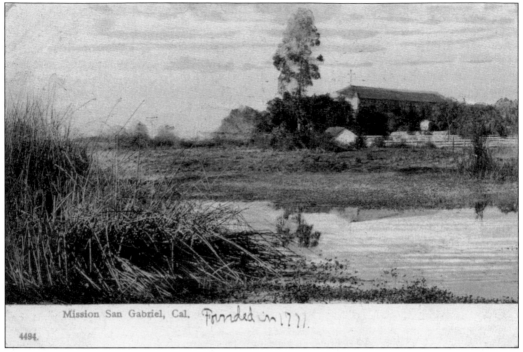

Mission San Gabriel, Cal. Founded in 1771.

4494.

The running stream, seen here in the foreground, was one of the reasons for the selection of the present site where the padres first raised a large cross and celebrated the first Mass in a wooden hut. This postcard, postmarked January 20, 1906, was sent to New Martinsville, West Virginia. (Published by the Paul C. Koeber Company, New York, New York.)

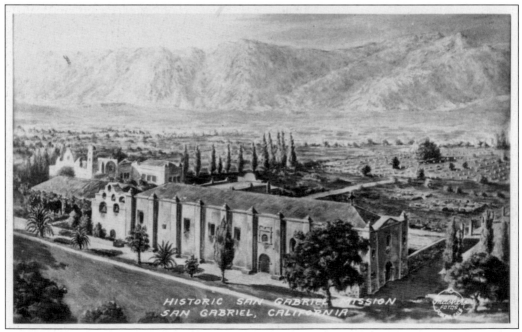

HISTORIC SAN GABRIEL MISSION
SAN GABRIEL, CALIFORNIA

Seen in this view is the mission and surrounding valley with the San Gabriel Mountains in the background. (Published by Frasher's, Inc., Pomona, California.)

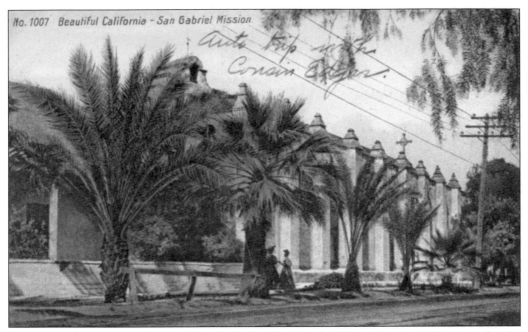

No. 1007 Beautiful California - San Gabriel Mission.

This view of the front of the mission includes the electrical lines that supplied power for the electric train that delivered tourists from all parts of Los Angeles County to visit the mission. The young date palms and the lone California fan palm, second from the left, grows in front of the mission. (Published by the Pacific Novelty Company, San Francisco, California.)

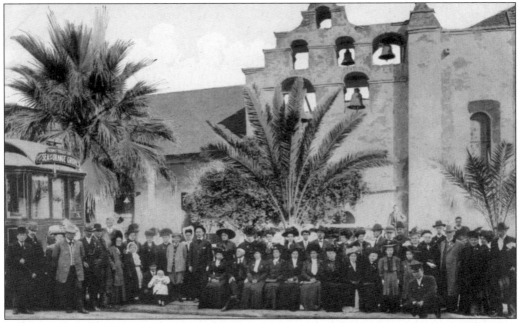

A group of tourists have posed for their photograph in front of the mission's campanario. The patrons of Tilton's Trolley Trip were guaranteed a visit through the mission at no extra charge, thereby saving 25¢. The sign on top of the electric train seen at left advertises the opportunity to visit a "Sea of Orange Groves." (Published by the Van Ornum Colorprint Company, Los Angeles, California.)

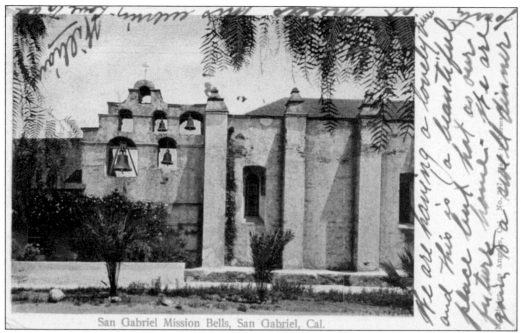

San Gabriel Mission Bells, San Gabriel, Cal.

Here is another view of the campanario with four of the six bells present. The original campanario was at the opposite end of the church; however, no drawings have been found that show how it originally looked. This postcard was postmarked in Los Angeles on August 30, 1905. (Published by M. Rieder, Los Angeles, California.)

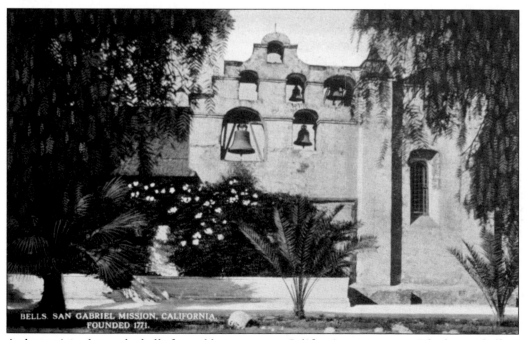

BELLS. SAN GABRIEL MISSION, CALIFORNIA. FOUNDED 1771.

A closer view shows the bells framed between two California pepper trees. The largest bell, at bottom left, is dated to about 1830. It weighs at least a ton and could originally be heard eight miles away in Los Angeles. (Published by Julius J. Hecht, Los Angeles, California.)

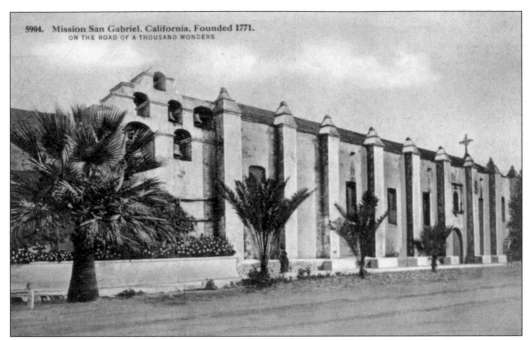

This postcard describes the mission as being "On the Road of a Thousand Wonders." Note that the cross is not seen atop the campanario in this image. (Published by the H. H. T. Company.)

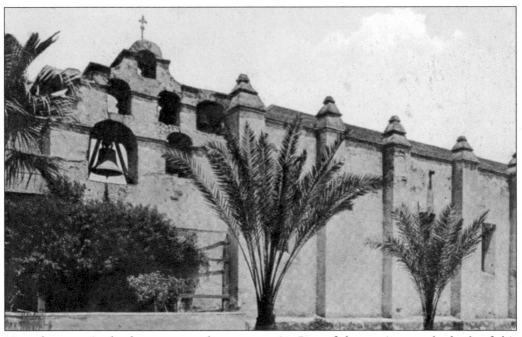

Here the cross is clearly seen atop the campanario. Part of the caption on the back of this postcard reads, "All missions were first temporary structures, as the Native Americans became expert in making building materials the buildings now in evidence were erected. San Gabriel was always a most important establishment." (Published by the Cardinell Vincent Company, San Francisco, California.)

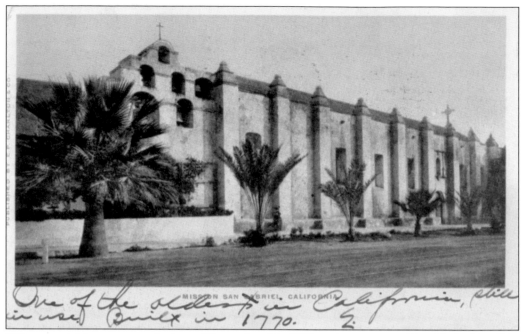

This postcard has a postmark date of December 18, 1905, and was sent to New York City. The handwritten message states that the mission was built in 1770, which is incorrect. (Published by E. P. Charlton and Company.)

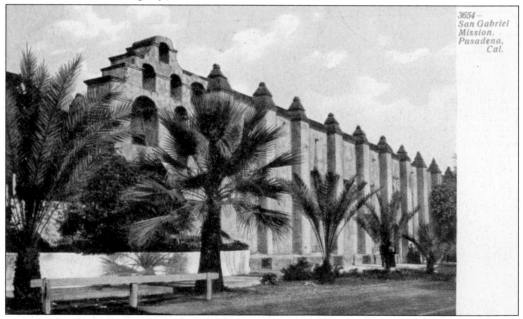

Here again the cross is seen missing from atop the campanario. Many of these older postcards were hand tinted from old photographs that might not have clearly shown all the detail in the image, so the cross could have been unintentionally omitted. The back of this postcard includes the printed passage on the left side that reads, "Writing on this part of the address side permitted after March 1, 1907." (Published by the Adolph Selige Publishing Company, St. Louis–Leipzig–Berlin.)

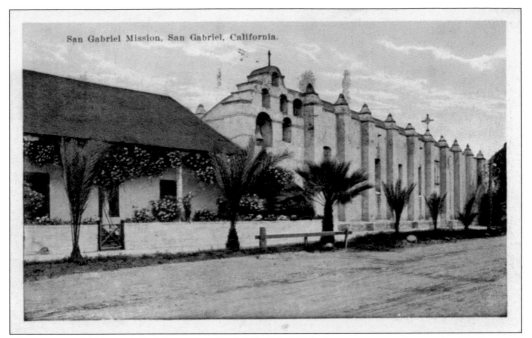

This postcard of San Gabriel, postmarked July 28, 1925, has a message that reads, "Where we will visit when leaving Los Angeles. Next mailing place will be San Diego, CA. Love to all, R. B. Hulse." (Published by S. H. Kress and Company.)

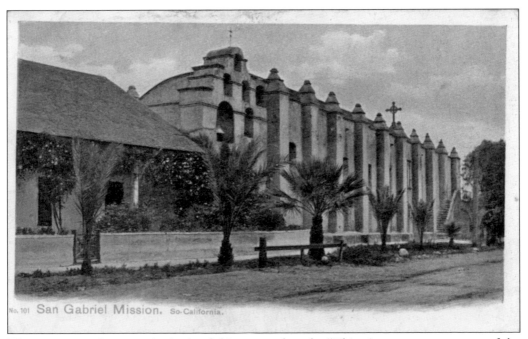

The message written on the back of this postcard reads, "This picture represents one of the oldest missions of the early days of California. California was founded and civilized by the Roman Catholic priests." (Published by Chas. Weldner, San Francisco, California.)

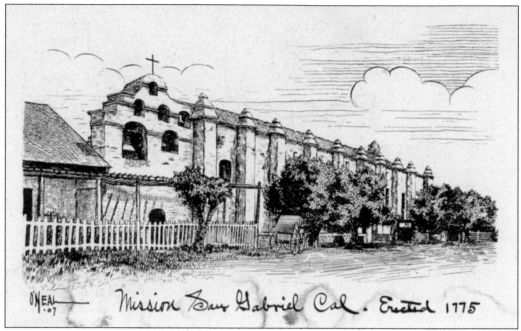

This postcard dated November 22, 1909, includes a fine pen-and-ink drawing of the mission by an artist named O'Neal and signed in 1907. Several horse-drawn carriages are stationed in front of the mission. (Publisher unknown.)

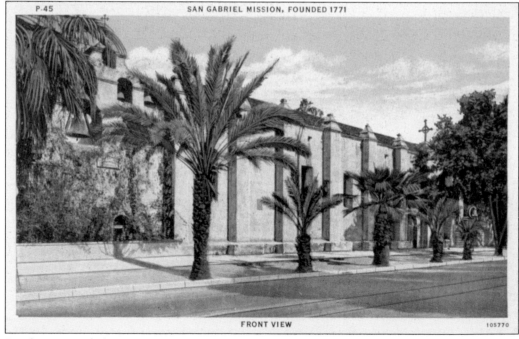

By the time of this postcard's printing, part of the front of the church was obscured by vegetation. The electric train tracks can still be seen at lower right. (Published by the Western Publishing and Novelty Company, Los Angeles, California.)

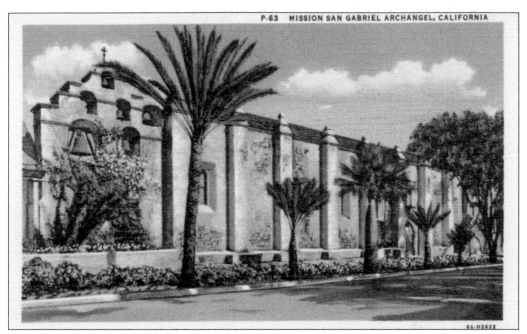

Here the date palm at left has reached an even greater height. Barely visible is the top bell in the campanario. Cast in Medford, Massachusetts, in 1828, it was sold by San Gabriel to the Plaza Church in Los Angeles, where it remained for 100 years until its return to the mission in 1931. (Published by the Western Publishing and Novelty Company, Los Angeles, California.)

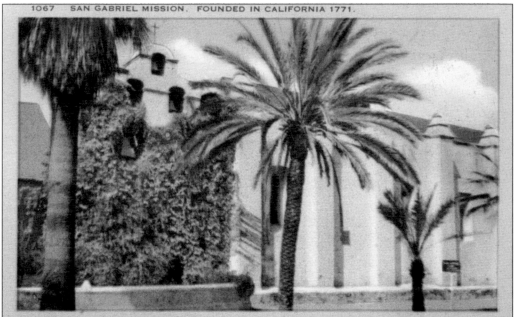

1067 SAN GABRIEL MISSION. FOUNDED IN CALIFORNIA 1771.

According to the caption on this postcard, "The unique architecture of San Gabriel Mission is shown in its flying buttresses, outside stairway and in the bell tower with its several arches built to correspond to the different sizes of the bells. For many years until the Pueblo de Los Angeles built a church, the largest bell was rung two hours before the services to give the settlers ample time to arrive in their oxcarts." (Published by the Longshaw Card Company, Los Angeles, California.)

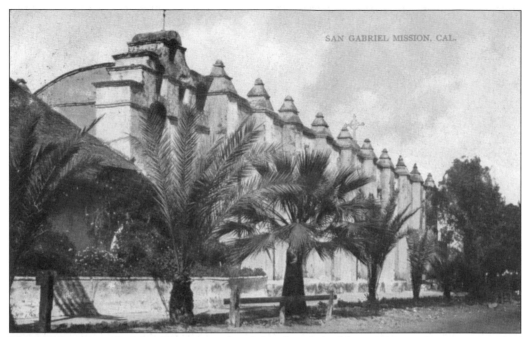

Pictured here is a slightly different angle of the church building. This card was postmarked January 7, 1908, and sent to New York. (Published by L. E. Severn, Los Angeles, California.)

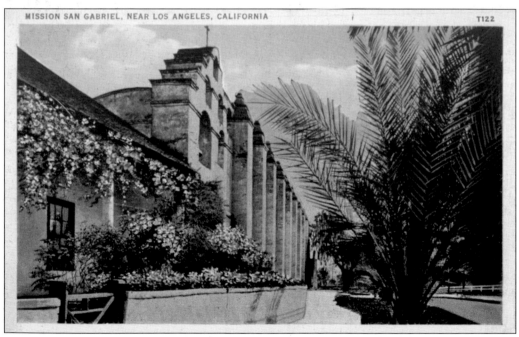

A portion of the flowering vines is hanging under the eaves at left. Despite some hardships during its early years, San Gabriel was actually quite prosperous by mission standards and also served as the spiritual center for the surrounding ranchos. (Published by Tichnor Art Company, Los Angeles, California.)

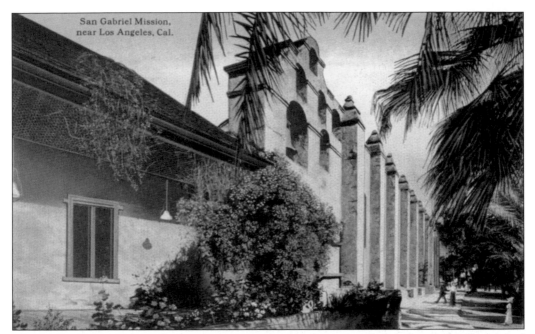

This roof, modern in its appearance, is in stark contrast compared with San Gabriel's original roof, composed of matted tule branches used to cover the rafters. Chicken wire was attached under the eaves to accommodate the flowering vines. (Published by the Western Publishing and Novelty Company, Los Angeles, California.)

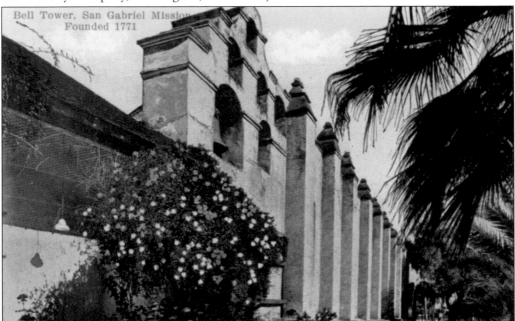

The architecture of San Gabriel is sometimes described as "fortress style" in reference to the capped buttresses, which are found at no other missions. Some experts have traced its origins to the Cathedral of Cordova, which was formerly a mosque with capped buttresses. This symbol of Christianity possibly had its architectural origins in Islam. (Published by the M. Kashower Company, Los Angeles, California.)

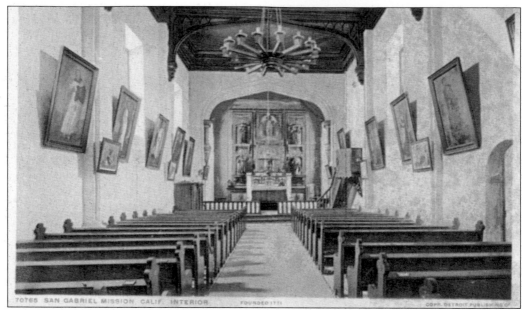

Here is the interior of the Great Church of San Gabriel. Outside light entering the sanctuary casts a green hue, which is caused by the tinted windows. The ceiling crossbeams are supported, scroll-sawn arches that were installed in the 19th century. This altar, originally produced in Mexico City, was brought to the mission sometime during the 1790s. (Published by the Detroit Publishing Company, Detroit, Michigan.)

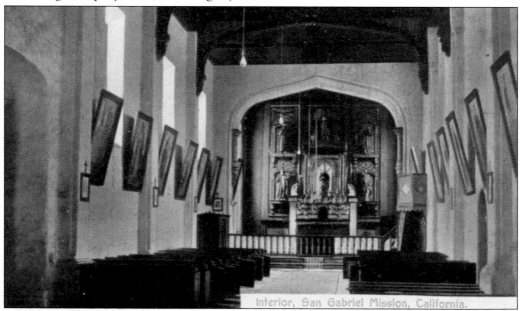

Still on view today in this inner sanctuary is the famous painting of the Virgin Mary that saved the founding padres from a Native American attack while they were seeking a location for the new mission. During the encounter with the Gabrielino/Tongva Indians, one of the padres showed the painting, which amazingly caused the Native Americans to lay down their weapons and begin placing gifts before the image of the Virgin Mary. (Published by the Newman Postcard Company, Los Angeles, California.)

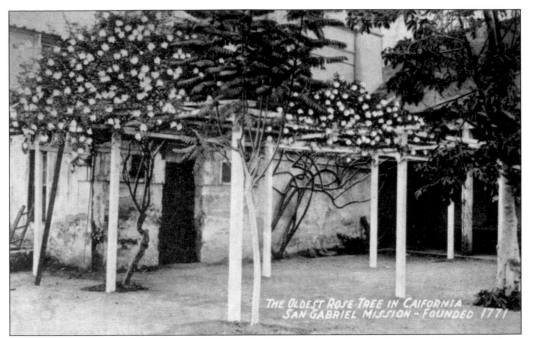

Postmarked March 3, 1917, this card shows the "Oldest Rose Tree in California" growing atop a trellis located in the inner courtyard. (Published by the Van Ornum Colorprint Company, Los Angeles, California.)

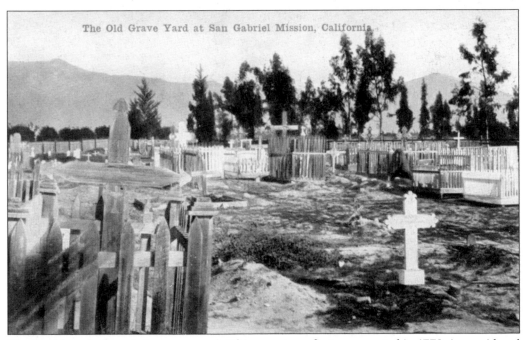

Depicted here is the mission graveyard. This cemetery, first consecrated in 1778, is considered the oldest one in Los Angeles County. It is believed that there are over 6,000 Native Americans buried here. (Published by the Van Ornum Colorprint Company, Los Angeles, California.)

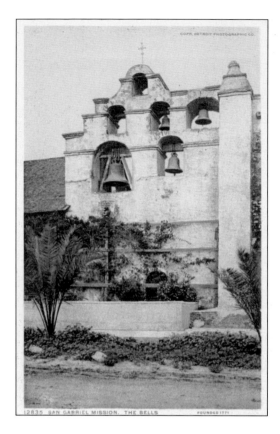

This postcard offers a closer glimpse of the mission bells. The Holbrook Company of Massachusetts, whose founder, Maj. G. H. Holbrook, learned his trade from Paul Revere, manufactured the smallest bell, seen in the center of the campanario. The bell at far right is believed to have been cast in Mexico City around 1795 by Paul Ruelas. (Published by the Detroit Publishing Company, Detroit, Michigan.)

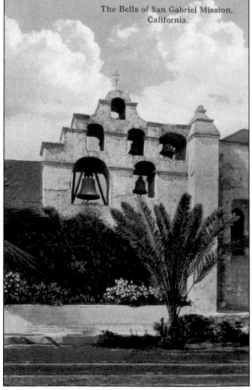

Another similar image of the campanario is seen in this postcard. (Published by the Western Publishing and Novelty Company, Los Angeles, California.)

Paul Ruelas also produced the small bell at lower right in 1795. It was created in the heavy Mexican style. Note the long, narrow window at right. Such windows are not found in any of the other missions. (Published by the Newman Postcard Company, Los Angeles, California.)

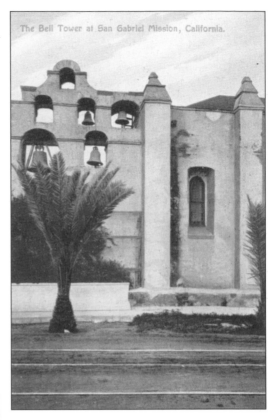

The Bell Tower at San Gabriel Mission, California.

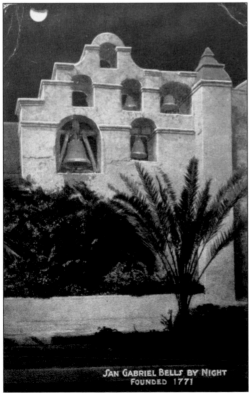

SAN GABRIEL BELLS BY NIGHT
FOUNDED 1771

Here is a night view of the previous scene depicting the mission illuminated by moonlight. (Published by Van Ornum Colorprint Company, Los Angeles, California.)

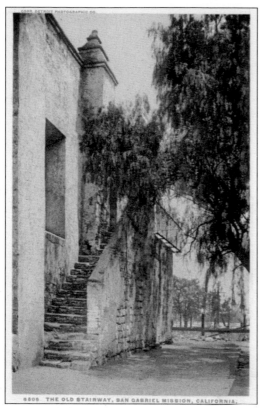

The "Old Stairway" leading up into the church is pictured here. The missing plaster below the steps at right has exposed some of the hard-burned bricks that rest atop a stone foundation. (Published by Detroit Publishing, Detroit, Michigan.)

One of the most photographed features of Mission San Gabriel is the Old Stairway. At far right is one of the bells of El Camino Real. The idea to install bells as markers along El Camino Real, or "The Royal Road," came about in 1906 when the first cast-iron bell was designed by Mrs. A. S. C. Forbes and was installed in front of the Plaza Church in Los Angeles. By 1913, a total of 425 bells were placed along the highway connecting the missions. (Published by the Williamson Haffner Company, Denver, Colorado.)

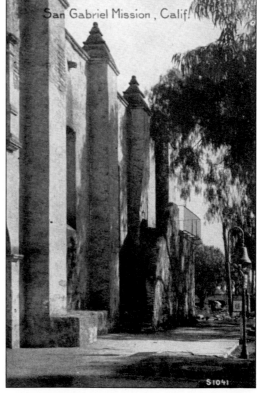

Pictured here are two boys enjoying a rest at the base of the Old Stairway. The steps of this old stairway have been worn down by the feet of Native American neophytes as well as countless others over the years. (Published by the S. H. Kress and Company.)

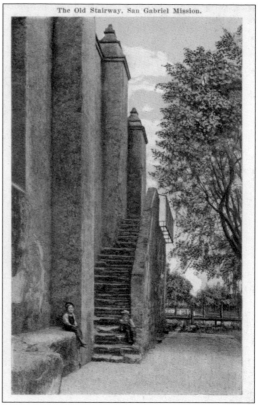

The Old Stairway, San Gabriel Mission.

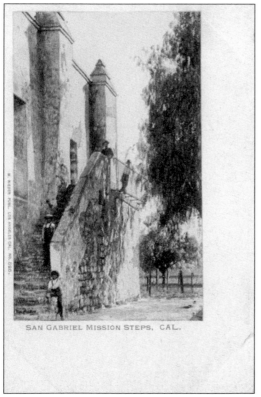

SAN GABRIEL MISSION STEPS, CAL.

A view with another group of boys on the Old Stairway is seen in this postcard. (Published by M. Rieder, Los Angeles, California.)

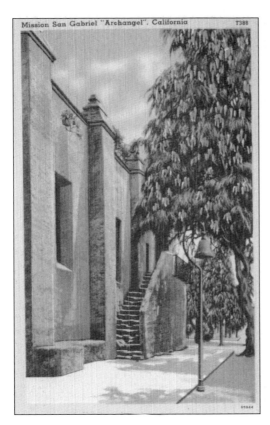

Mission San Gabriel "Archangel", California T388

Here again, the bell signifying El Camino Real can be seen at right. Throughout the structure of the church, stone was used for construction as high as the bottom of the windows, seen here above the stairway. The rest of the structure is composed of adobe brick. It is thought this method of construction was designed to strengthen the building against earthquakes. (Published by the Tichnor Art Company, Los Angeles, California.)

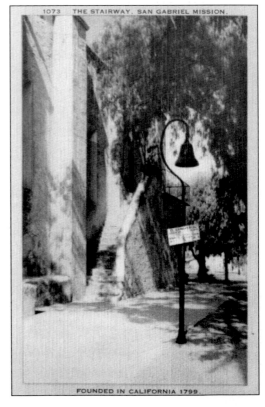

1073 THE STAIRWAY, SAN GABRIEL MISSION.

FOUNDED IN CALIFORNIA 1799.

A portion of the caption on the reverse of this postcard reads, "On the direct route from Mexico to Monterey, the San Gabriel Mission, noted for its abundant crops, was the first supply station after crossing the mountains and desert. This road, called 'El Camino Real' (The Royal Road), extended from Guatemala to San Francisco, and is marked in California by bronze bells." (Published by the Longshaw Card Company, Los Angeles, California.)

This view includes the old wooden door seen at left. The walls of the church are more than 4 feet thick, with portions of the buttresses up to 7 feet thick. (Published by the Western Publishing and Novelty Company, Los Angeles, California.)

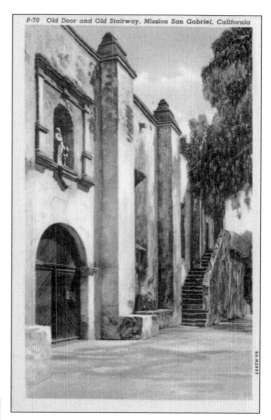

P-70 Old Door and Old Stairway, Mission San Gabriel, California

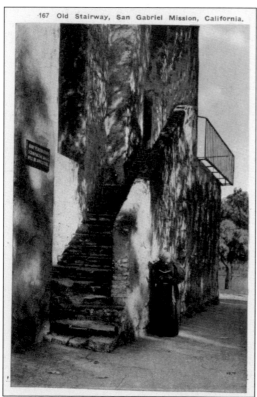

167 Old Stairway, San Gabriel Mission, California.

Here a lone priest is seen quietly reading scripture beside the aged stairway. (Published by the M. Kashower Company, Los Angeles, California.)

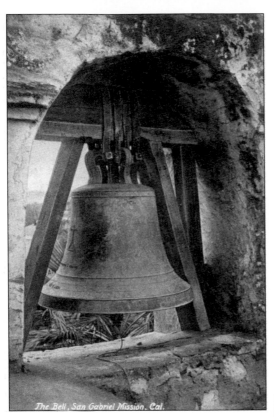

The Bell, San Gabriel Mission. Cal.

This postcard provides a close-up view of the largest of the mission bells. Believed to have been cast around 1830, the bell is attached by its crown-shaped top, the symbol of a royal bell. (Published by M. Rieder, Los Angeles, California.)

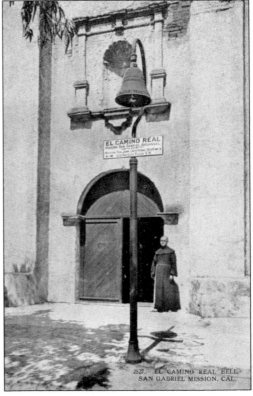

EL CAMINO REAL

2527. EL CAMINO REAL BELL. SAN GABRIEL MISSION. CAL.

This postcard features a close-up of the bell of El Camino Real. The caption on the reverse reads, "El Camino Real is the Spanish name for the historic road joining the twenty-one missions. It is 700 miles long and is marked by one of these picturesque guide posts at every mile." (Published by the Western Publishing and Novelty Company, Los Angeles, California.)

Pictured here is the baptistery room inside the church. The original hand–hammered copper baptismal font and silver baptismal shell, brought from Spain in 1771, are seen inside. This room and its items are still in use today. (Published by the Detroit Publishing Company, Detroit, Michigan.)

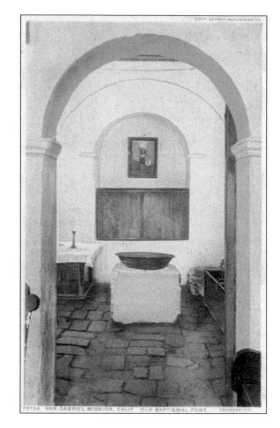

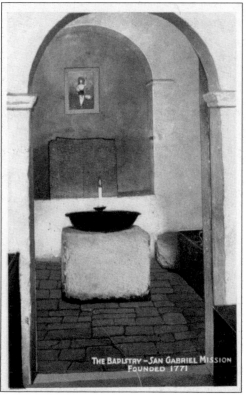

In this similar view of baptistery, a lighted candle can be seen. (Published by the Pacific Novelty Company, San Francisco and Los Angeles, California.)

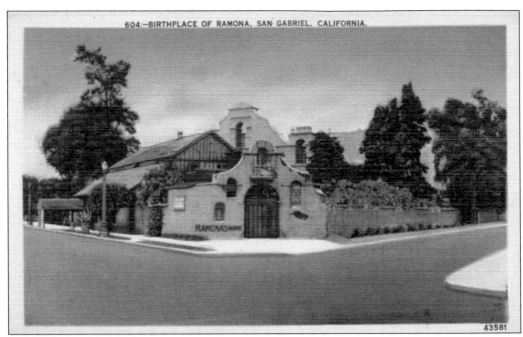

604:—BIRTHPLACE OF RAMONA, SAN GABRIEL, CALIFORNIA.

43581

Just across the street from the mission church is the "birthplace of Ramona." *Ramona* was the name of the famous novel by author Helen Hunt Jackson about the great love between a young California maiden, Ramona, and a Native American, Alessandro. (Published by the Gardener-Thompson Company, Los Angeles, California.)

Ramona's Birthplace, San Gabriel, California

T389

67468

Within this enclosure lives the famous San Gabriel grapevine, which is said to be the parent of all California grapes. Planted in the 18th century, it continues to thrive today. (Published by the Tichnor Art Company, Los Angeles, California.)

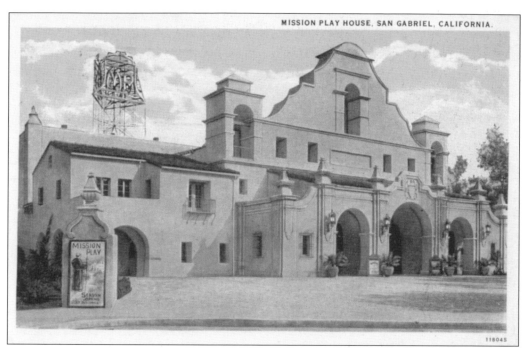

Adjacent to the enclosure housing the oldest grapevine is the Mission Play House, as seen in this card postmarked April 4, 1930. An advertisement for the mission play is seen at left. (Published by the Western Publishing and Novelty Company, Los Angeles, California.)

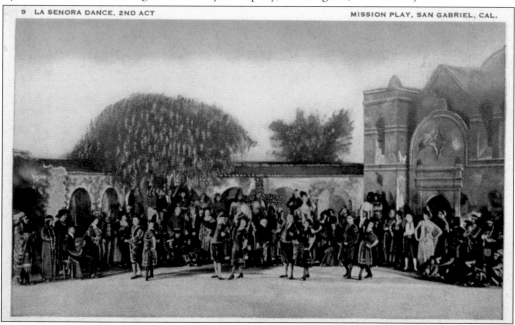

9 LA SENORA DANCE, 2ND ACT MISSION PLAY, SAN GABRIEL, CAL.

Here is an actual scene from the second act of the mission play entitled *La Senora Dance*, written by California historian John Steven McGroarty in 1911. A three-hour pageant, it involved hundreds of actors. The play ran for over 20 years, and more than two million people paid admission to see it. (Published by the Pacific Novelty Company, San Francisco and Los Angeles, California.)

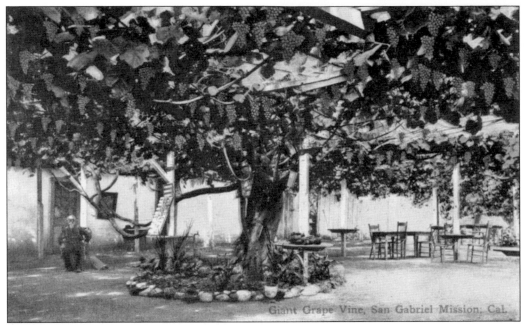

Pictured here is the giant grapevine said to be the first one planted in California and still growing today. At one time, San Gabriel operated the largest winery in all of California, which included three wine presses. (Published by the Van Ornum Colorprint Company, Los Angeles, California.)

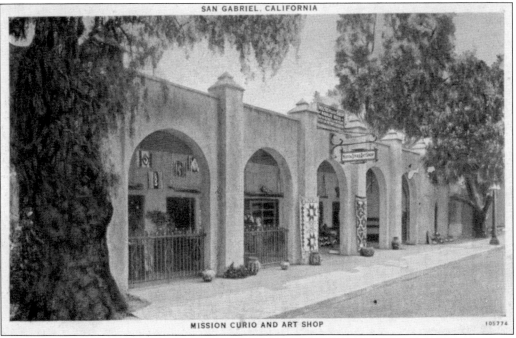

This postcard shows the Mission Curio and Art Shop, which claimed to have "one of the most interesting and complete collections of Mexican and Native American crafts on exhibition in California." (Published by the Western Publishing and Novelty Company, Los Angeles, California.)

Five

MISSION SAN FERNANDO REY DE ESPAÑA

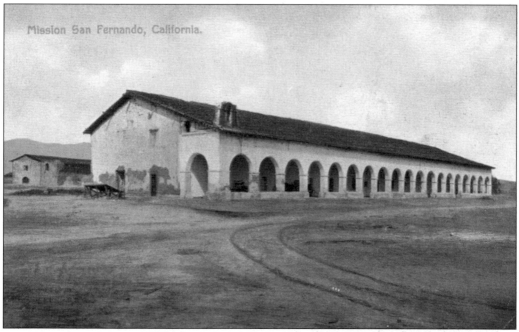

Mission San Fernando, California.

Named for St. Ferdinand, king of Spain, Mission San Fernando was founded by Fr. Fermin Lasuén on September 8, 1797, as the 17th mission. The original church building was completed in 1799 but was replaced the following year. A third church was completed in 1806, but it was damaged, as were many of the other missions, by the earthquake of 1812. The location chosen for the mission was supposed to be halfway between Missions San Gabriel and San Buenaventura, but San Fernando was actually much closer to San Gabriel. The selected site was actually on land already belonging to an early Spanish settler, Francisco Reyes, who was the alcalde of Los Angeles. Some historians maintain that Reyes was eventually evicted from the land, which was then turned over to the church. (Published by the Newman Postcard Company, Los Angeles, California.)

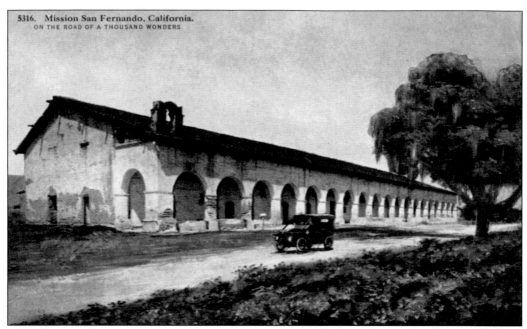

Here a lone antique automobile is seen in front of the Convento, or "Long Building," which measures 243 feet long and 50 feet wide. Along its length, the colonnade was composed of 19 arches. The Convento was never actually part of the mission quadrangle and once served as a hospice with part of it set aside for visitors. (Published by H. H. T. Company.)

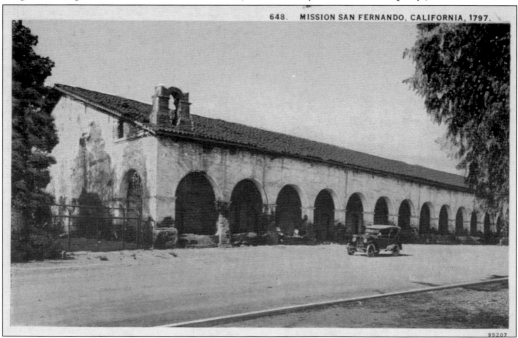

A similar view is seen here with another old car passing in front of the Convento. This structure managed to survive mostly intact after the church became ruins, possibly because it was set apart from the rest of the mission quadrangle. (Published by the Western Publishing and Novelty Company, Los Angeles, California.)

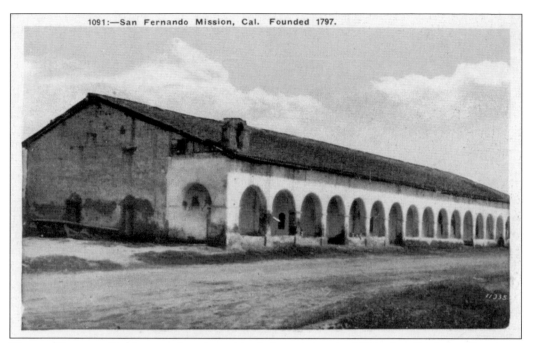

Henry Chapman Ford, an artist who visited the mission in 1888, described the Convento as "well preserved. The rooms are now used for the purposes of the Porter Land and Water Company and in the rear some are used as a stable." (Published by the M. Kashower Company, Los Angeles, California.)

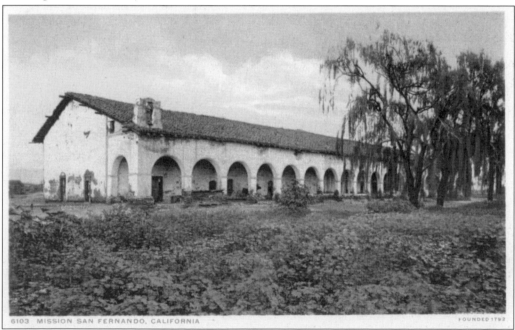

6103 MISSION SAN FERNANDO, CALIFORNIA FOUNDED 1792

In 1896, another writer described the Convento's dilapidated condition as having been "desecrated by bits of harness, old wagons, grain bags, a kitchen and sleeping quarters for ranch hands, and all sorts of odds and ends." As for the courtyard behind the Convento, he wrote, "Hogs are everywhere." (Published by the Detroit Publishing Company, Detroit, Michigan.)

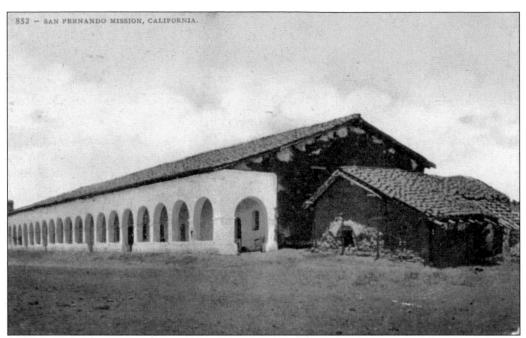

The smaller structure seen at right was known as the majordomo's house and was where the foreman of the mission ranch resided. This postcard was postmarked November 28, 1910, and mailed to New Brunswick, Canada. (Published by Edward H. Mitchell, San Francisco, California.)

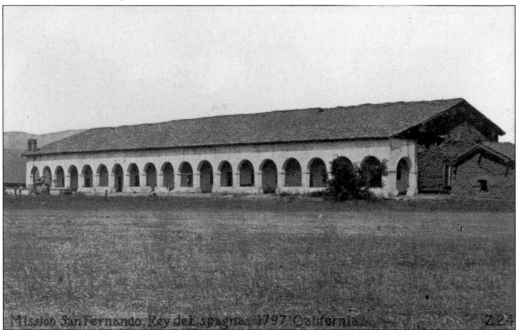

Mission San Fernando, Rey de Espagna, 1797 California Z.24

It took 13 years to build the Convento, which was completed in 1822. Along the front corridor, 20 of its 21 Roman arches can be seen in this view. Currently this building houses the Teatro de Fray Junipero Serra, which shows movies about early mission life. (Published by the Souvenir Publishing Company, San Francisco and Los Angeles, California.)

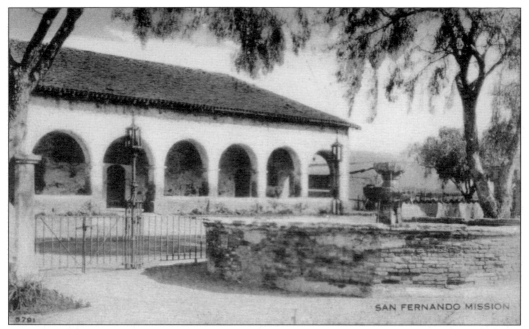

This fountain was once located in front of the Convento but now resides in a park that is separated from the mission by San Fernando Mission Boulevard. (Published by Sunny Scenes, Inc., Winter Park, Florida.)

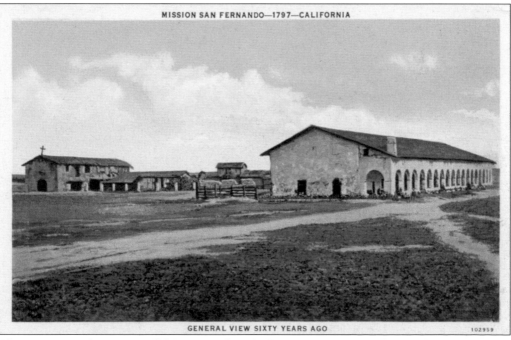

The caption on the reverse of this postcard reads, "Mission San Fernando Rey de España, 1797. General view 60 years ago, showing the workshops of the Indians between the old church and the monastery. Of these workshops, where the Indians used to learn a trade, only a few ruins are left." (Published by Curt Teich and Company, Chicago, Illinois.)

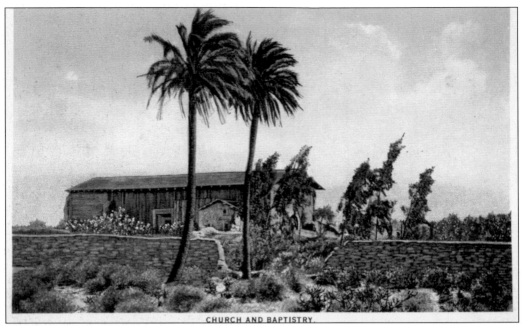

CHURCH AND BAPTISTRY.

The caption on the back of this postcard reads, "Mission San Fernando Rey de España founded 1797. Church with Baptistery, finished 1812. In this building the Indians assembled for services every morning and night. The exterior is of very simple architecture, but the interior was elaborately adorned." (Published by Curt Teich and Company, Chicago, Illinois.)

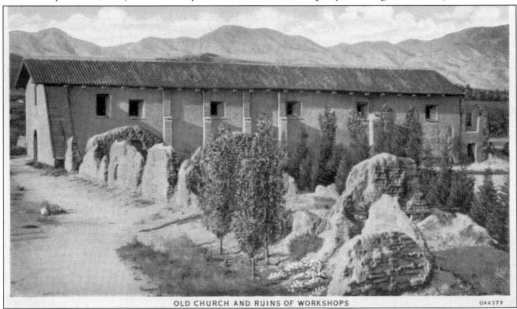

OLD CHURCH AND RUINS OF WORKSHOPS OA4379

The caption on the reverse of this postcard reads, "The old church was built in 1812. An earthquake destroyed the tower. Efforts are made at present to restore the old building. In the mountains shown in the background, the first gold was found in California in 1849." The reference to gold in the caption is regarding the incident when a majordomo from one of the ranchos pulled up some onions for dinner one day and noticed some flakes of gold attached in the roots. (Published by Curt Teich and Company, Chicago, Illinois.)

This postcard illustrates the "Arcade of Cloister," which served the same function as a front porch would on a house—providing shade in the summer and cover from rain in the winter. (Published by Curt Teich and Company, Chicago, Illinois.)

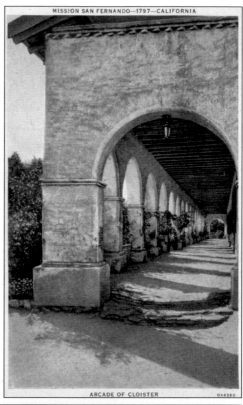

Another view of the arches is seen here. A portion of the caption on the back of this postcard reads, "The mission stands in one of the most fertile and picturesque of valleys." (Published by the Newman Postcard Company, Los Angeles, California.)

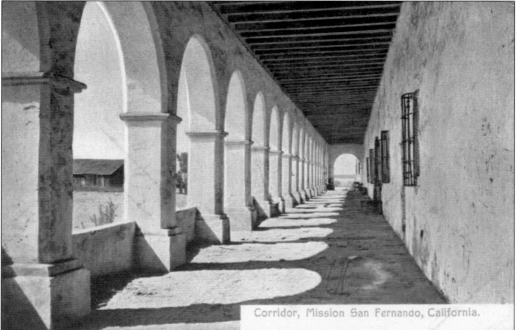

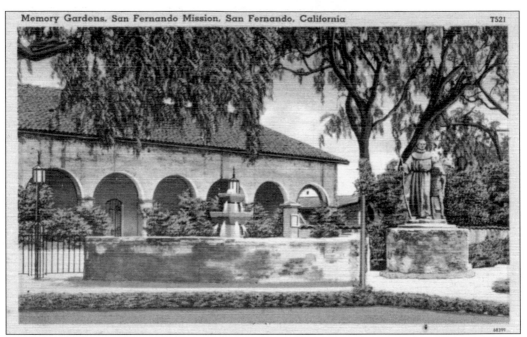

Located in the Memory Garden of the park just across the street from the Convento are the fountain and the statue of Father Serra with Native American youth (right). (Published by the Tichnor Art Company, Los Angeles, California.)

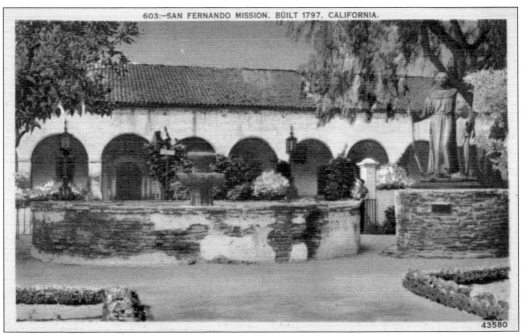

603:—SAN FERNANDO MISSION. BUILT 1797. CALIFORNIA.

A closer view of the fountain and statue is seen in this postcard. A portion of the caption on the reverse describes the mission: "It is located near the city of San Fernando surrounded with the beautiful semi-tropical trees and flowers of California." (Published by the Gardner-Thompson Company, Los Angeles, California.)

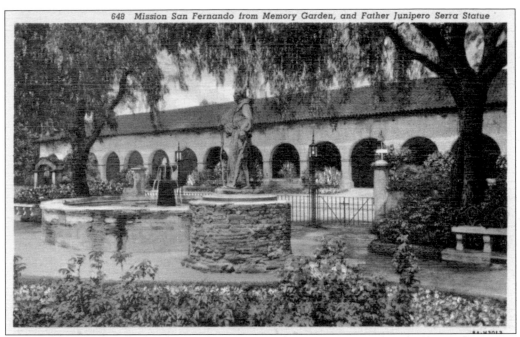

A side view of the statue of Father Serra walking with the Native American youth is pictured here. Part of this postcard's caption reads, "Mission San Fernando Rey de España, the seventeenth mission, is situated in the beautiful San Fernando Valley, about twenty miles northwest from Los Angeles." (Published by the Western Publishing and Novelty Company, Los Angeles, California.)

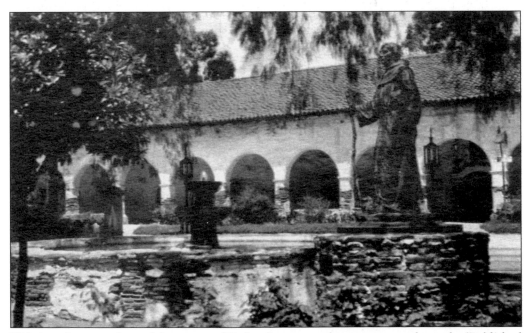

This is a close-up view of the statue of Father Serra near the entrance to the park. (Published by the Fidelity Reproduction Company, Los Angeles, California.)

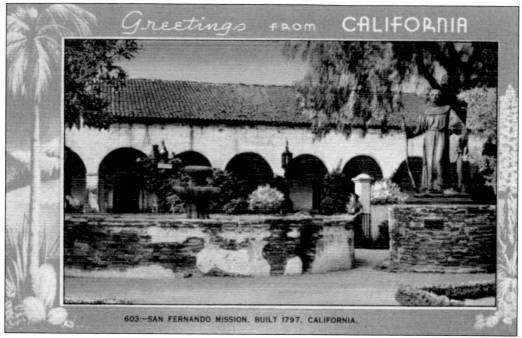

Bordered by a palm tree and a yucca in bloom (right), this postcard shows the fountain and the statue. (Published by the Gardner-Thompson Company, Los Angeles, California.)

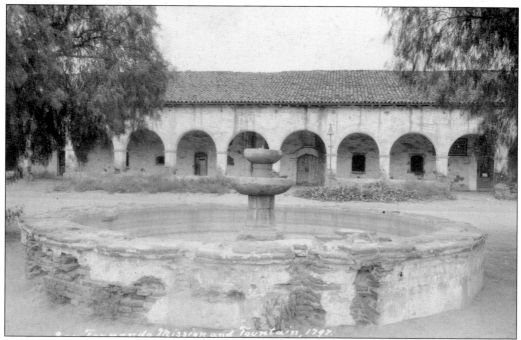

This RPPC features the original fountain located about 30 feet from its original location. Built in 1812, it was fashioned after a replica in Cordova, Spain. Located near the fountain are the old soap works and the reservoir. (Publisher unknown.)

Six

MISSION
SAN BUENAVENTURA

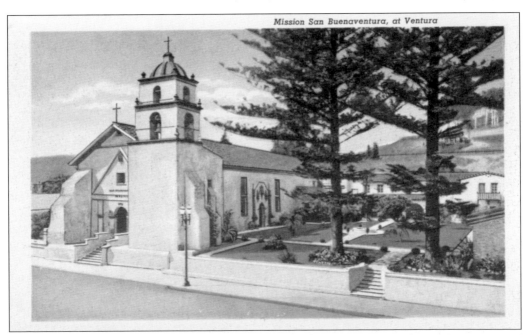

Mission San Buenaventura, at Ventura

Originally planned to be the third mission, San Buenaventura, named after St. Bonaventure, actually became the ninth, founded on Easter Sunday, March 31, 1782, by Fr. Junipero Serra. It was the last mission to be founded by Padre Serra, who was assisted that day by Padre Pedro Benito Cambón. Note the two large Norfolk Island pine trees (*Araucaria heterophylla*) seen on the right side of the mission in this old postcard. (Published by the Stanley A. Piltz Company, San Francisco, California.)

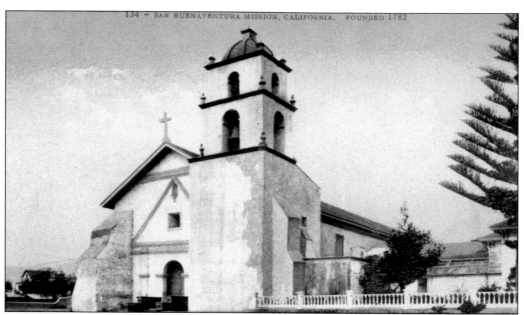

After the founding, Padre Cambón was placed in charge of the mission and supervised the construction, which began with a chapel, dwellings, stockade, and a 7-mile-long aqueduct to bring water from the Ventura River to the mission. With the available water, San Buenaventura was able to establish a bountiful orchard that English explorer George Vancouver described as "the finest he had seen." (Published by Edward Mitchell, San Francisco, California.)

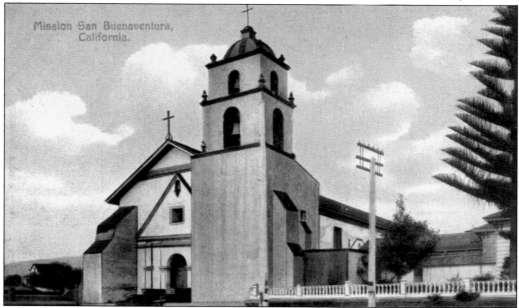

Mission San Buenaventura, California.

In 1793, Vancouver's party of men were allowed to load 20 pack mules with fresh fruits and vegetables from the mission gardens to transport to his ship, which was anchored off the Santa Barbara coast. According to Vancouver, the first church building was destroyed by fire. The reconstruction was performed by local Chumash Indians under the direction of Padre Cambón, who was reported to have given the Native Americans payment in the form of beads. (Published by the Newman Postcard Company, Los Angeles, California.)

84

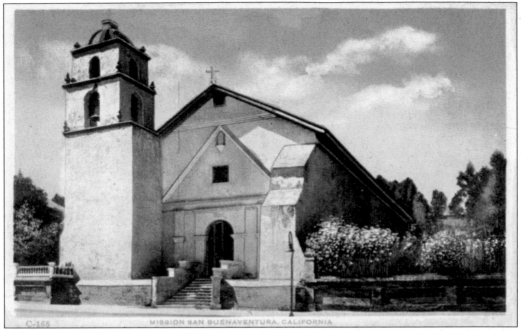

Obviously, this postcard was produced with the negative reversed. The mission's bell tower is on the left instead of on the right, where it actually stood. Note the placement of the small bell of El Camino Real attached to the pole in the foreground. (Published by the Mission Curio and Art Shop, San Gabriel, California.)

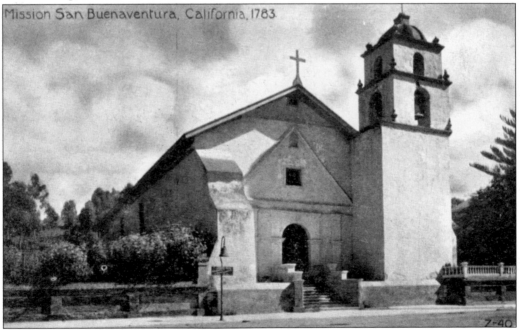

Artist Alfred Robinson, another early visitor to the mission, described its great agricultural abundance and wrote in 1829 that it grew "apples, pears, peaches, pomegranates, tunas (prickly pear cactus fruit), and grapes." (Published by the Pacific Novelty Company, San Francisco, California.)

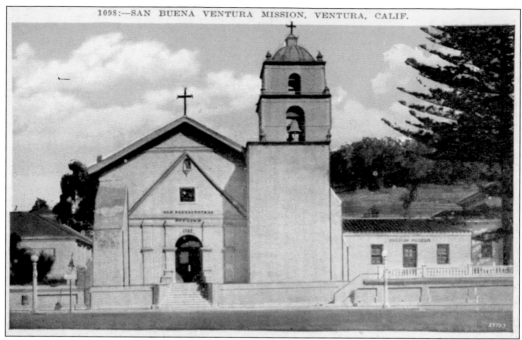

The view in this postcard illustrates the addition of the mission museum at right. Drawings made of the mission during the 1850s show that another similar structure once existed to the right of the bell tower. (Published by the M. Kashower Company, Los Angeles, California.)

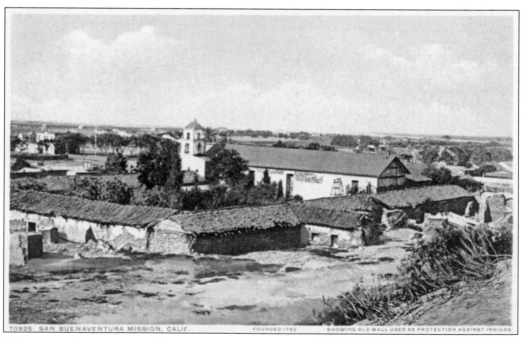

This postcard was produced from a photograph taken in 1875. It shows the quadrangle as seen from the hill behind the mission. The caption on the lower right portion of the postcard claims the old adobe wall was built for protection against Native American attacks. (Published by the Detroit Publishing Company, Detroit, Michigan.)

Seven

MISSION SANTA BÁRBARA

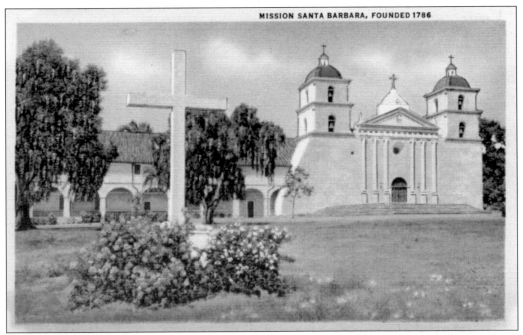

MISSION SANTA BARBARA, FOUNDED 1786

The "Queen of the Missions," Mission Santa Bárbara was named after St. Barbara because it was founded on the day of the Feast of St. Barbara, December 4, 1786. The 10th California mission, it was originally conceived of by Father Serra in 1782, but because of his death in 1784, it was actually founded by Fr. Fermin Lasuén, who afterwards placed Padre Antonia Paterna in charge. During the early years, three adobe churches were constructed, each somewhat larger than the previous. The earthquake of 1812 destroyed the third church. The fourth church, completed in 1820, is the one seen today, except for the second tower, which was added in 1831. In the foreground of this postcard, a large cross can be seen at left. (Publisher unknown.)

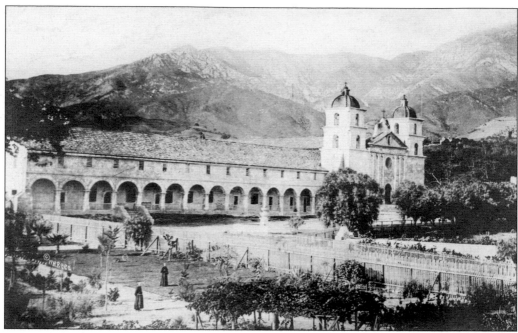

Here is an RPPC of the mission and mountains in the background. The monastery is seen to the left of the church building. Two priests are seen on the mission grounds at lower left. (Publisher unknown.)

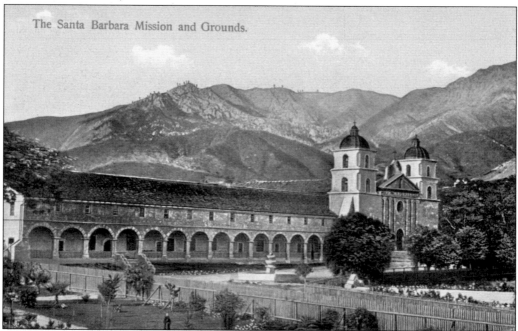

Here is a hand-drawn version of the previous image. Santa Bárbara is unique among missions for having two identical towers as part of its church architecture. The caption on the reverse of this postcard reads, "This beautiful mission was founded in 1786. It is the best preserved of the missions, constructed entirely out of stone, and services are held here daily." (Published by M. Rieder, Los Angeles, California.)

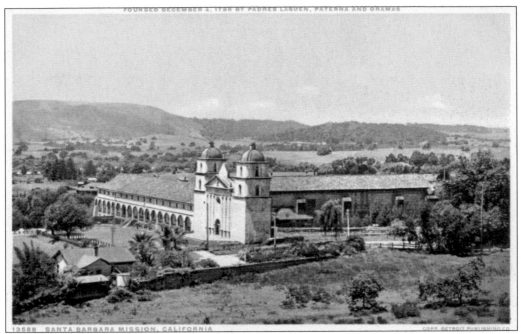

13588 SANTA BARBARA MISSION, CALIFORNIA COPR. DETROIT PUBLISHING CO.

A portion of the classical Roman architectural design can be seen in the central facade of the church in this postcard. The design was copied from a book of architecture produced by the Roman writer Vitruvious. After an earthquake struck in 1925, both towers suffered severe damage to their domes, and it took two years to repair them. (Published by the Detroit Publishing Company, Detroit, Michigan.)

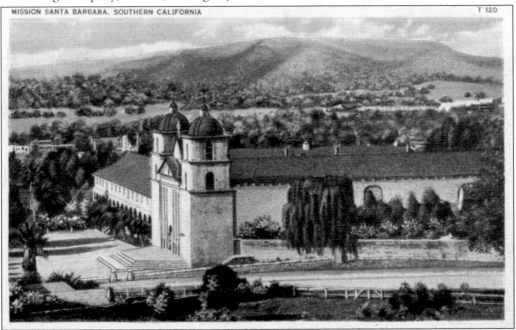

MISSION SANTA BARBARA, SOUTHERN CALIFORNIA T 120

This is a closer view of the church and its Roman architecture. Just outside the church and cemetery grounds can be found the remains of the mission's aqueduct. (Published by the Tichnor Art Company, Los Angeles, California.)

89

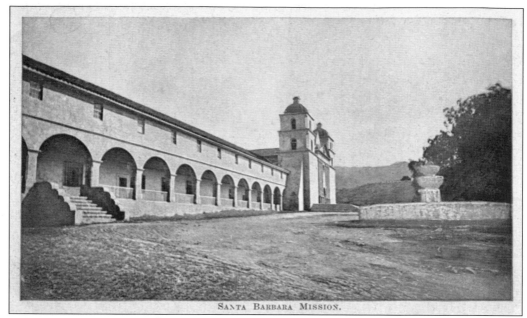

SANTA BARBARA MISSION.

In the foreground at right is the mission's fountain, built in 1808. The monastery wing and its colonnade are to the left side of the church. The rooms of this wing now house a series of exhibits, including a kitchen, Chumash Indian art room, and another room displaying the oldest known photographs of the mission. (Published by M. Rieder, Los Angeles, California.)

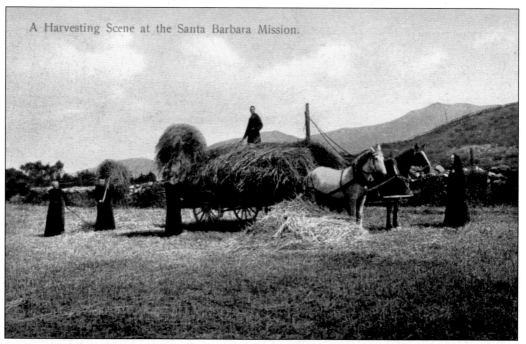

A Harvesting Scene at the Santa Barbara Mission.

Here a group of priests loads hay on a wagon. The Franciscans at Santa Bárbara grew abundant crops of wheat, barley, corn, and beans. They also had plentiful orchards of oranges, olives, and grapes. Postmarked in Los Angeles on June 13, 1907, this postcard was sent to Florence, Italy. (Published by M. Rieder, Los Angeles, California.)

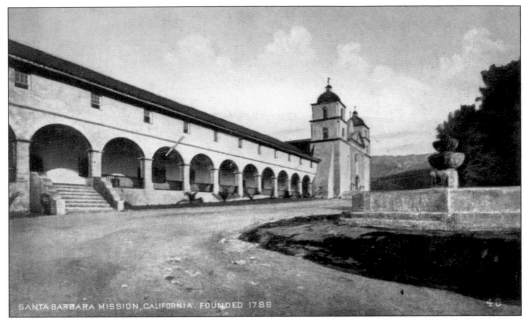

A portion of the caption on the reverse of this old postcard reads, "This interesting old mission is still occupied by the Franciscan Fathers, which order founded all the missions of Alta California. It is here that Father Zephyrin Engelhardt, the historian has written (from the Santa Bárbara Archives and other sources), his valuable and authentic 'Missions and Missionaries of California,' the only true history of these interesting establishments." (Published by the Pacific Novelty Company, San Francisco, California.)

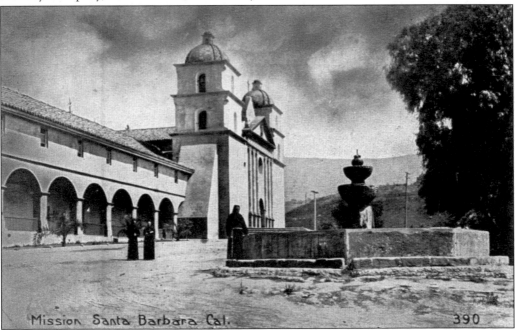

A group of priests are seen near the mission's Moorish fountain. The overflow from this fountain runs into a stone laundry basin, where the Native American women at one time washed their clothes. (Published by Edward H. Mitchell, San Francisco, California.)

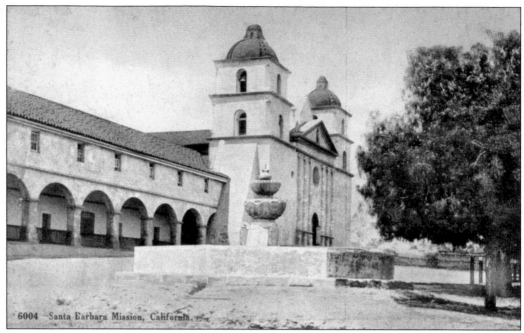

The beautiful mission fountain is the central image of this postcard, which was sent June 12, 1919, to Lawndale, California. A portion of the written message on the reverse reads, "Dear Helen, We are coming to see you folks Saturday. I am going to mothers and Gertie is going to drive us over, Florence." (Published by the Williamson Haffner Company, Denver, Colorado.)

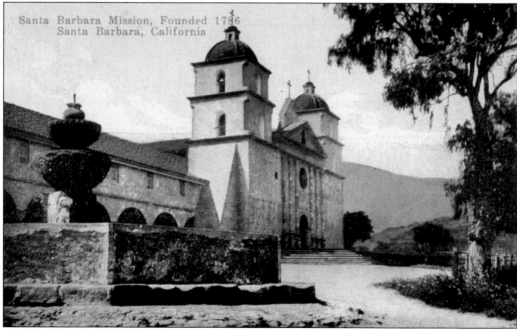

A closer view of the fountain is seen here. In 1950, cracks began to appear in the tower, which was rebuilt after the 1925 earthquake with concrete that chemically degraded so badly that the front of the church had to be disassembled and later reconstructed with steel-reinforced concrete. (Published by the M. Kashower Company, Los Angeles, California.)

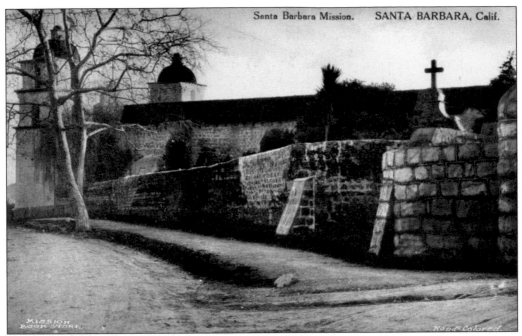

This postcard depicts the back view of the mission just outside the wall of the cemetery. Many of Santa Bárbara's historical figures are buried within these cemetery grounds. (Published by the Albertype Company, Brooklyn, New York.)

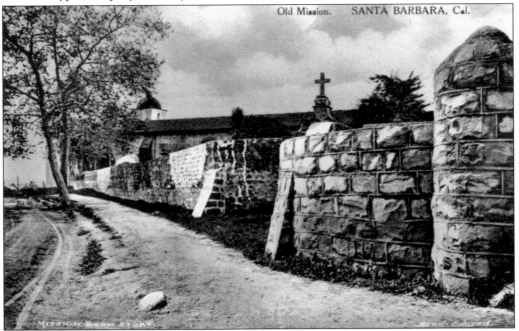

Here is a similar view of the wall surrounding the cemetery. Along with Santa Bárbara's other notable settlers, approximately 4,000 Native Americans are buried here, including "The Lone Woman of San Nicolas Island," Juana Maria, who was discovered in 1853 on San Nicolas, living alone for most of her life. She was brought to Santa Bárbara but died within seven weeks of arriving on the mainland. (Published by the Albertype Company, Brooklyn, New York.)

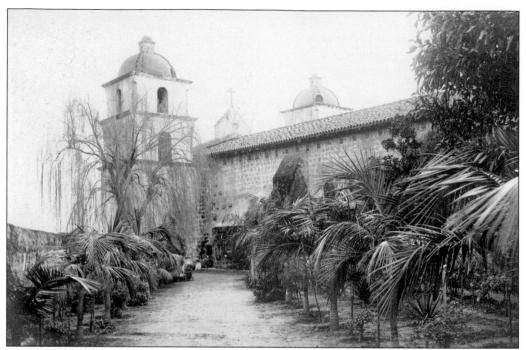

Seen here in this RPPC are rows of palm trees planted along the path within the cemetery grounds. (Publisher unknown.)

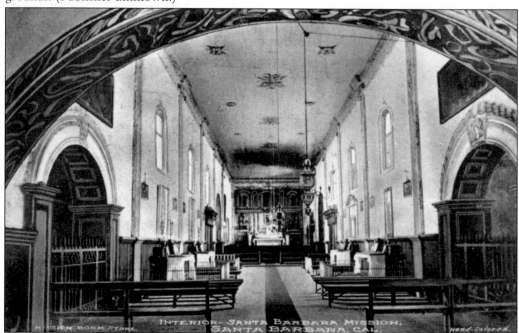

The interior of the church of Santa Bárbara is viewed in this postcard produced from a photograph taken in 1898. The arches, seen at the top and at the sides, as well as the pilasters were decorated with an attractive imitation marble. Two of the 200-year-old paintings found within this church are believed to be the largest in any of the California missions. (Published by the Albertype Company, Brooklyn, New York.)

94

A lone priest is seen here with one of the mission's bell towers in the background. (Published by the Detroit Publishing Company, Detroit, Michigan.)

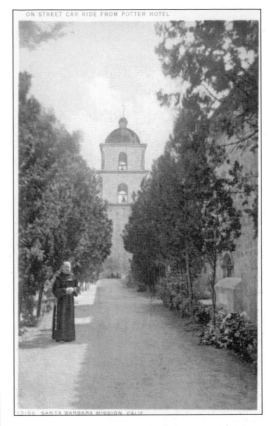

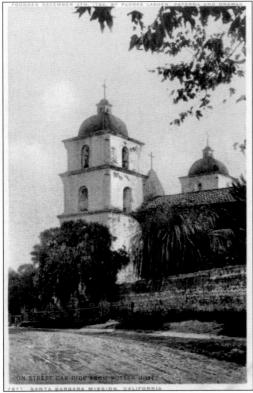

Another view just outside the wall of the cemetery shows both bell towers. (Published by the Detroit Publishing Company, Detroit, Michigan.)

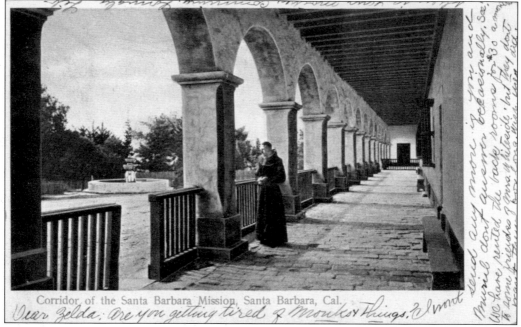

Corridor of the Santa Barbara Mission, Santa Barbara, Cal.

Dear Zelda: Are you getting tired of monks & things.

The corridor of the monastery, with a lone priest posing in quiet contemplation, is seen in this postcard that was postmarked November 1, 1906. Part of the message written on the front reads, "Dear Zelda, Are you getting tired of monks & things?" Perhaps Zelda had recently received several other California mission postcards. (Published by M. Rieder, Los Angeles, California.)

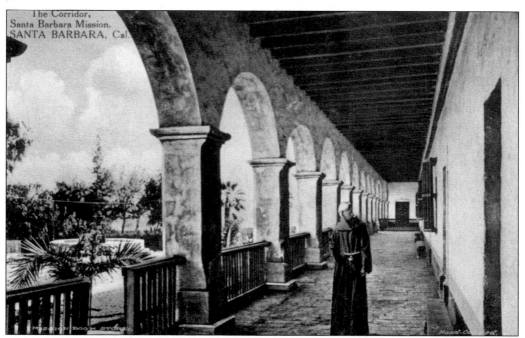

The Corridor,
Santa Barbara Mission.
SANTA BARBARA, Cal.

A very similar view of the previous postcard is seen here. In very small type at the lower left corner can be read, "Mission Book Store." (Published by the Albertype Company, Brooklyn, New York.)

This postcard is titled, "The Garden Crucifix, Santa Barbara Mission, California." A priest can be seen in prayer before a depiction of the crucifixion in the cemetery grounds of the mission. Calla lilies are in bloom in the foreground of this image. (Published by the Detroit Publishing Company, Detroit, Michigan.)

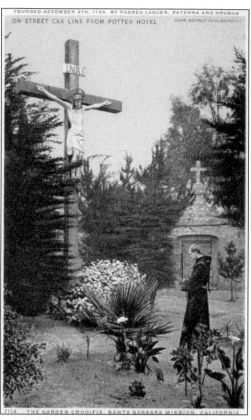

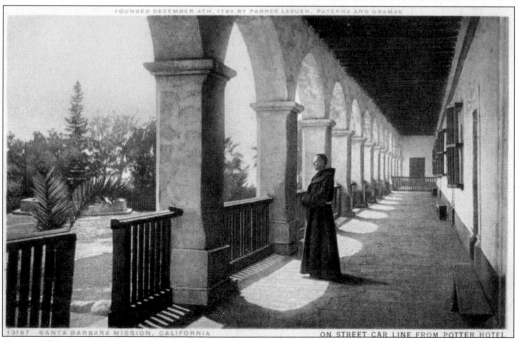

Depicted here is another scene of a lone priest standing inside the corridor. (Published by the Detroit Publishing Company, Detroit, Michigan.)

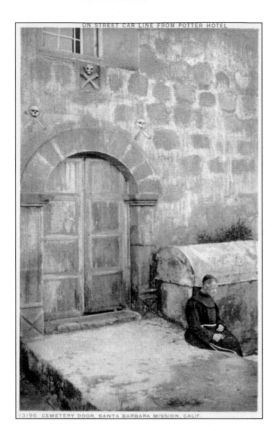

Here a priest is seated before the Roman-arched doorway that leads from the church to the cemetery. (Published by the Detroit Publishing Company, Detroit, Michigan.)

In this RPPC, a priest is standing before the church doorway while gazing upon a calla lily in bloom. The skull and crossbones directly above the door were carved in stone. However, the two skull and crossbones on either side of the door are real human remains and were embedded in the mortar between the stones. (Publisher unknown.)

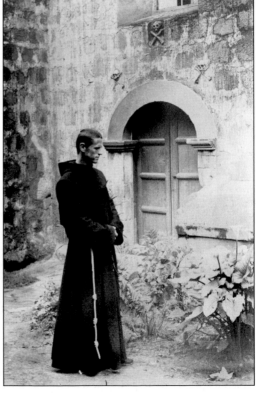

Eight

MISSION SANTA INÉS

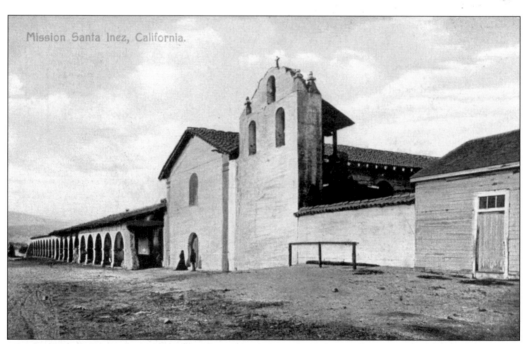

Mission Santa Inez, California.

Founded by Padre Estevan Tapis on September 17, 1804, Santa Inés is unique for being the only California mission founded during the first decade of the 19th century. It was named after St. Agnes and was also the last mission established in Southern California. The building seen in this postcard was actually dedicated in 1817 after the earthquake of 1812 destroyed the original mission. (Published by the Newman Postcard Company, Los Angeles, California.)

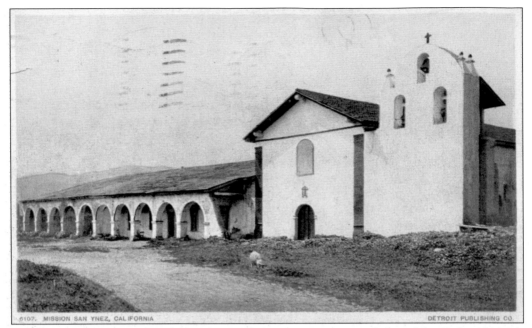

Santa Inés flourished in part due to its elaborate water system, designed by Father de Uría to bring water from the neighboring mountains. The padres were then able to produce an abundance of grain crops such as wheat, barley, and corn. (Published by the Detroit Publishing Company, Detroit, Michigan.)

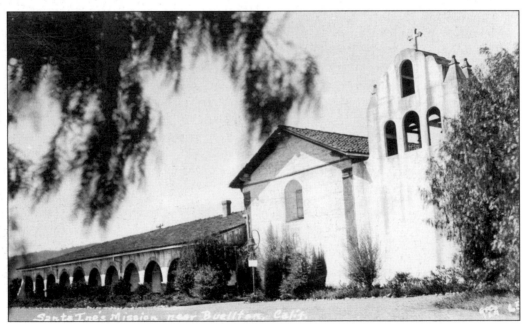

The campanario has arched openings for four bells. After the first campanario collapsed in 1911, it was replaced with this one constructed of concrete, which itself was replaced again in 1948. (Publisher unknown.)

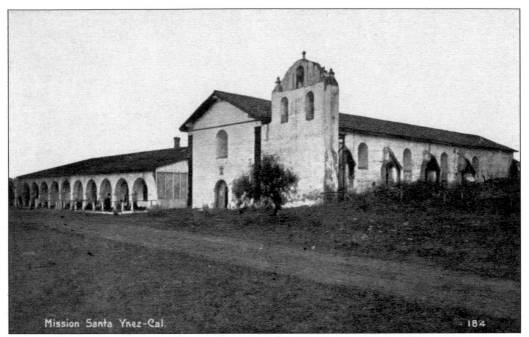

Mission Santa Ynez-Cal. 184

With its Moorish influence, the campanario of Santa Inés somewhat resembles that of Mission San Gabriel, probably because the padre who designed it came from Mission San Gabriel. (Published by Edward H. Mitchell, San Francisco, California.)

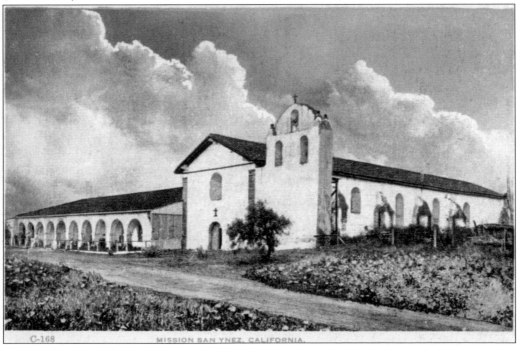

C-168 MISSION SAN YNEZ, CALIFORNIA.

A portion of the caption on the reverse of this postcard reads, "At this mission is to be noted the large brick reservoir and other evidence of the engineering abilities of the early fathers and their labor in developing the resources of the surrounding lands for the support of the Christianized Indians." (Published by the Mission Curio and Art Shop, San Gabriel, California.)

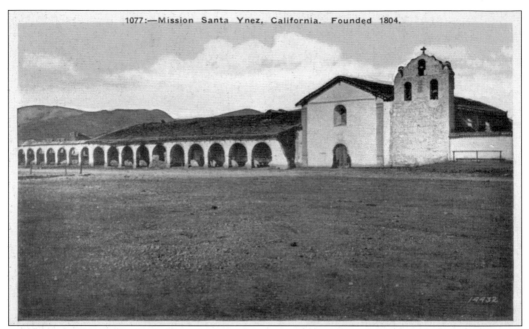

Here a portion of the original 24 arches is visible at left. The roof of the monastery had collapsed by this time. (Published by the M. Kashower Company, Los Angeles, California.)

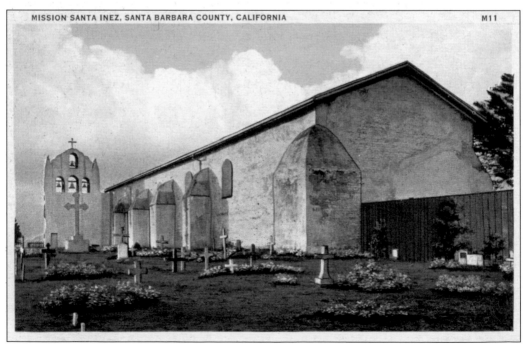

MISSION SANTA INEZ, SANTA BARBARA COUNTY, CALIFORNIA M11

Seen here is the small graveyard adjacent to the church and behind the campanario. Note the four bell niches within the concrete campanario. Within this cemetery rest the bones of up to 1,600 Native Americans. (Published by News Stand Distributors, Los Angeles, California.)

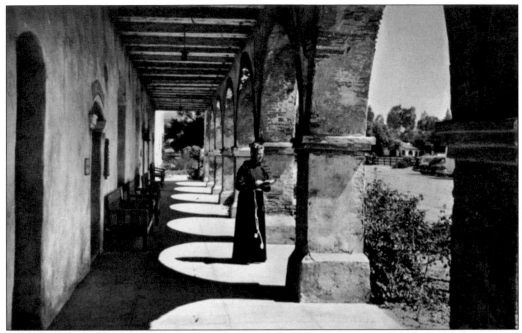

A lone priest walks within the arches of the promenade in this postcard. To the left of the priest is the room that now houses the mission gift shop and also leads to the vestment room, model room, artifacts room, Madonna Chapel, and the church. (Published by Bob Ball, Visalia, California.)

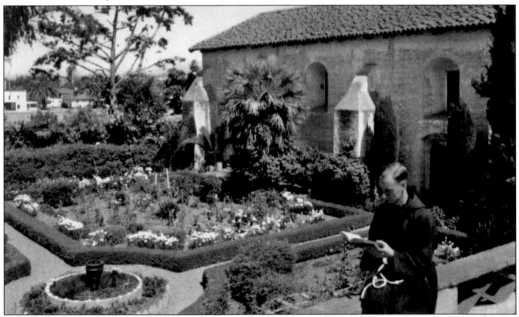

The caption on the reverse of this postcard reads, "A Capuchin Franciscan padre reads the ancient scriptures on the rear balcony of the Convento overlooking the old mission gardens. In the right background is the original side door to the church which bears the design of the 'River of Life' carved by Indian craftsmen about 1820." (Published by the H. S. Crocker Company, San Francisco, California.)

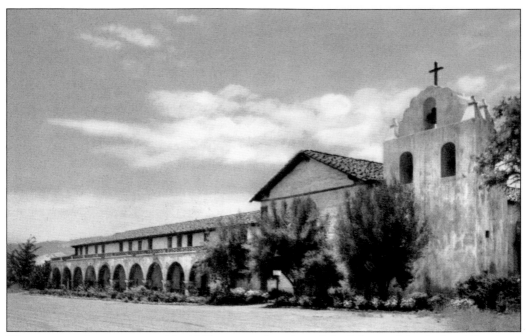

The campanario, constructed in 1948, returned to the original three-niche design. The three bells housed inside were cast in 1817, 1818, and 1897 and are rung from the tile roof platform at the rear of the structure. (Published by Anderson's Valley Inn, Buellton, California.)

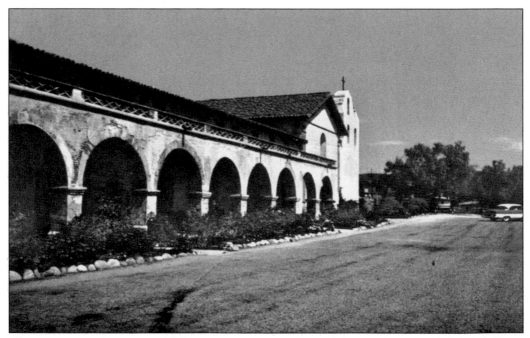

The caption on the reverse of this postcard reads, "One of the most typical of the California missions, Santa Inés is well known for its colorful mural decorations and handsome campanile." (Published by Bob Ball, Visalia, California.)

Nine

MISSION LA PURÍSIMA CONCEPCIÓN

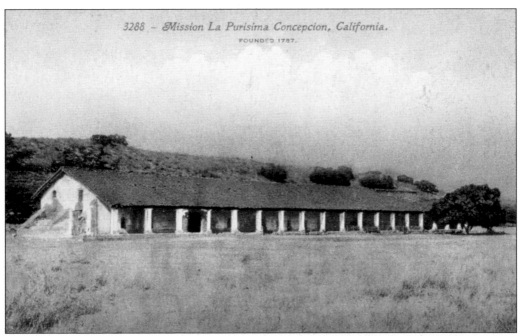

3288 – Mission La Purísima Concepcion, California.
FOUNDED 1787.

This mission's name translates to mean "the Immaculate Conception of Mary the Most Pure." Located near Lompoc, California, it was founded on December 8, 1787, by Fr. Fermin Lasuén and became the 11th mission. Construction began in March 1788, but the first mission site was abandoned after its complete destruction following the great earthquake of 1812. A new site was then selected four miles northwest of the original. (Published by the Souvenir Publishing Company, San Francisco, California.)

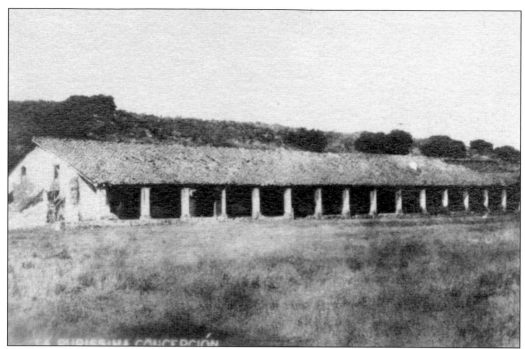

Here is an early photograph postcard of the monastery building at the mission. This building was once used as a private residence and, sadly, as a stable prior to its collapse. La Purísima was designed in a linear fashion, unlike the quadrangle design employed by all the other missions. (Publisher unknown.)

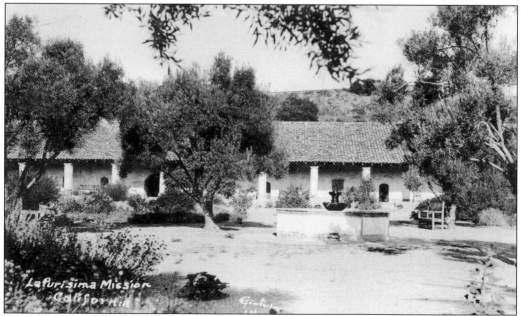

This RPPC shows a view of the center fountain at right, located within the mission gardens, and the padre's quarters in the background. This fountain once provided water for drinking, cooking, and watering the garden. Excess water ran into the *lavanderia* so the Native Americans could wash their clothes. (Publisher unknown.)

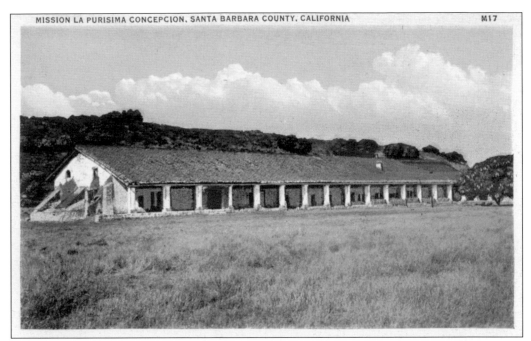

Another view of the monastery, or padre's quarters, is seen here. Historians are still uncertain why this mission was not built in the typical quadrangle design. One theory suggests it may have been selected to accommodate an easier evacuation in the event of another devastating earthquake. (Published by the News Stand Distributors, Los Angeles, California.)

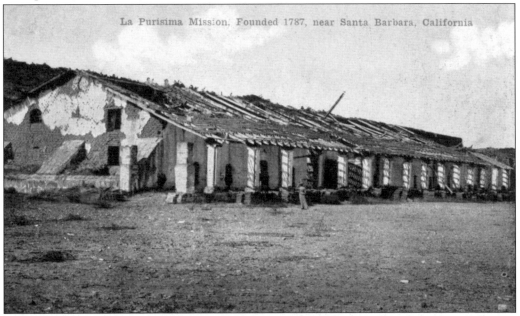

La Purisima Mission, Founded 1787, near Santa Barbara, California

The roof of the padre's quarters pictured here is near total collapse, which is eventually what happened. However, during the 1930s, the National Park Service and the CCC (Civilian Conservation Corps) took on the task of restoration, which resulted in the complete rebuilding of the mission in 1851. (Published by the Van Ornum Colorprint Company, Los Angeles, California.)

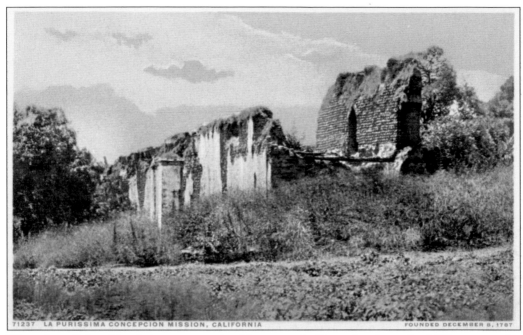

71237 LA PURISSIMA CONCEPCION MISSION, CALIFORNIA FOUNDED DECEMBER 8, 1787

The ruins of the old mission are seen in this postcard. Once the plaster had fallen away, the adobe was easily damaged by seasonal rains, which dissolved the old bricks back into the soil. In 1934, the Union Oil Company and the Catholic Church donated the land the mission was on to the State of California. (Published by the Detroit Publishing Company, Detroit, Michigan.)

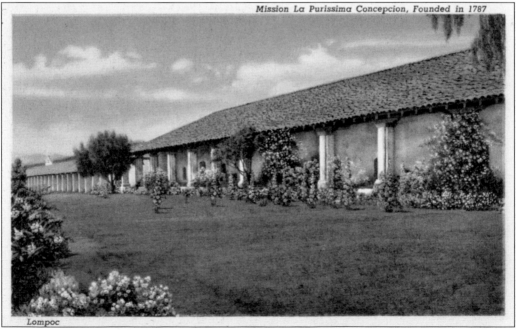

Mission La Purissima Concepcion, Founded in 1787

Lompoc

Looking southwest towards the church, the restored mission is pictured in this postcard. The top of the newly constructed campanario, modeled after the one at Santa Inés, is just barely visible at far left. La Purísima Mission State Park is considered the most complete restoration project of all the California missions. (Published by the Stanley A. Piltz Company, San Francisco, California.)

Ten

THE ASISTENCIAS AND OTHER VIEWS

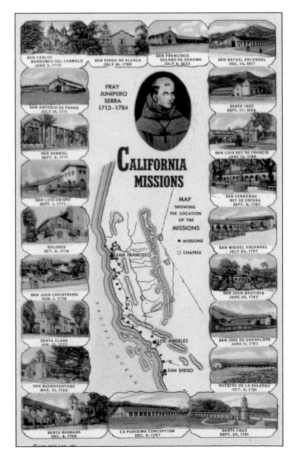

This postcard, which was postmarked June 15, 1948, depicts a map showing the location of the California missions. Fr. Junipero Serra is featured at the top center surrounded by illustrations of all 21 missions. A portion of the caption on the reverse reads, "The founding of the Spanish Missions in California furnished an epic in history. These historical monuments are reminders of the great Franciscan adventure." (Published by the Western Publishing and Novelty Company, Los Angeles, California.)

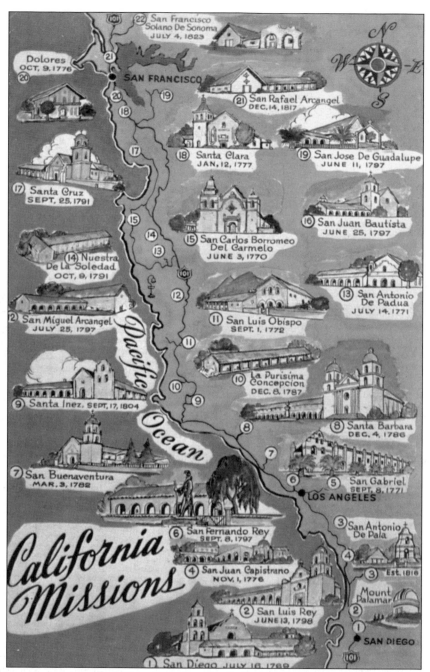

The caption on the reverse of this postcard reads, "The California Missions built between 1776 and 1831. Father Serra and the friars, who followed him, gathered the Yuma and Shoshone Indians (19,000) into communities to build mission houses, chapels and plant vineyards. With the overthrow of the Spanish power by the Mexicans there followed a period of destruction and neglect that continued till recent years. Helen Hunt Jackson's investigations caused the government to establish about 30 small reservations to care for the 2,600 remaining Native Americans. The work of restoring the missions is continuing, to enhance the beauty of California's heritage." (Published by Columbia Wholesale Supply, North Hollywood, California.)

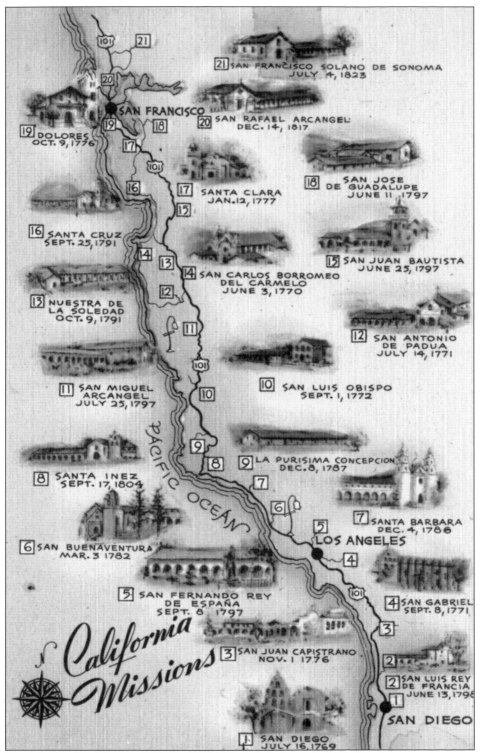

Here is another similar mission map postcard. (Published by Herz Postcards, San Diego, California.)

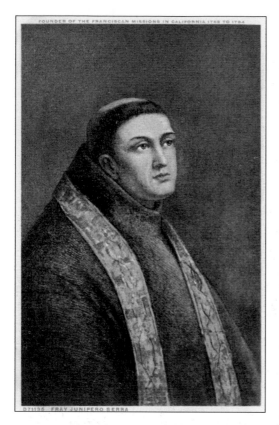

The man most responsible for the establishment of the California mission system was undoubtedly Padre Serra, who was born November 24, 1713, in Mallorca, Spain. He left his homeland in 1749 to begin his missionary services and arrived on New Year's Day, 1750, at the College of San Fernando in Mexico City. (Published by the Detroit Publishing Company, Detroit, Michigan.)

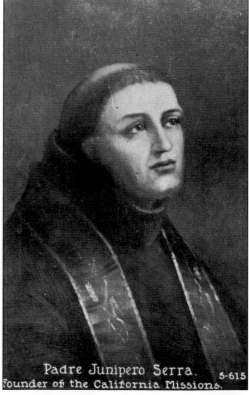

This postcard is a close-up view of the previous image. Father Serra was chosen by José de Gálvez, the visitador general of New Spain, to establish the missions in Alta California. He founded the first mission in San Diego on July 16, 1769. He continued his work until his death on August 28, 1784. (Published by Edward Mitchel, San Francisco, California.)

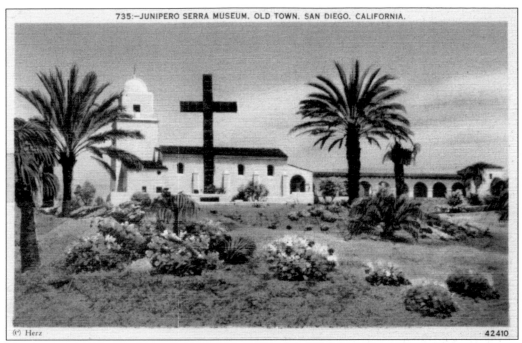

735:—JUNIPERO SERRA MUSEUM. OLD TOWN. SAN DIEGO. CALIFORNIA.

The caption on the reverse of this postcard reads, "The Junipero Serra Museum overlooks the Valley of the Missions on Presidio Hill, where California began. It was presented to the City of San Diego by George W. Marston." (Published by Herz Postcards, San Diego, California.)

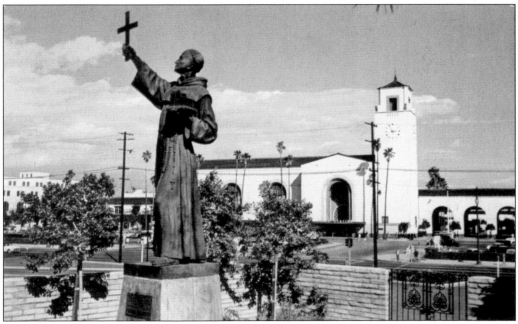

This statue of Father Serra was placed just across the street from Union Station in Los Angeles in remembrance of his life's work. Just out of view to the left of this statue is Olvera Street, the oldest street in Los Angeles. (Published by the Western Publishing and Novelty Company, Los Angeles, California.)

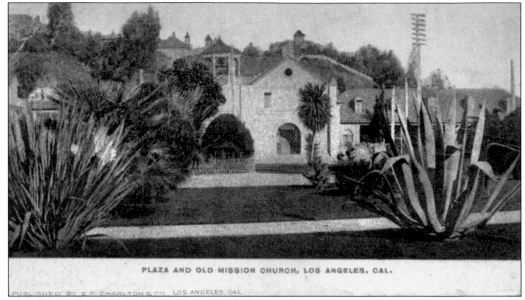

Although technically not one of the Spanish missions founded by the padres, the Old Mission Church of Los Angeles is nevertheless a part of Southern California's historic Spanish heritage. Its true name is Nuestra Señora Reina de Los Angeles, which means "Our Lady Queen of the Angels." The church was originally founded on September 4, 1781, by the *pobladores*, or early settlers of Los Angeles. A large agave plant can be seen at right. (Published by E. P. Charlton and Company, Los Angeles, California.)

The Plaza Church was originally considered an *asistencia*, or sub-mission, of Mission San Gabriel. Although the church was founded in 1781, the present building was not completed and dedicated until December 8, 1822, which was eight years after the laying of its first cornerstone. This postcard was sent to Phoenix, Arizona, and postmarked March 28, 1908. (Published by M. Rieder, Los Angeles, California.)

In the foreground of this postcard is one of the very large ficus trees that still stand in the plaza courtyard today. A report presented on June 19, 1839, described the church as having a leaky roof; extensive repairs were made between 1841 and 1842. (Published by the Newman Postcard Company, Los Angeles, California.)

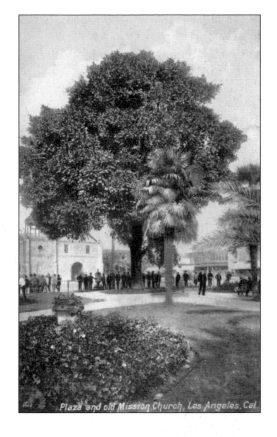

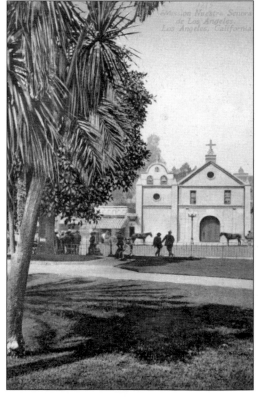

The church was remodeled again in 1861, with the front wall taken down and rebuilt with bricks instead of adobe. The original flat roof covered with brea (tar) was also replaced with a shingled roof. (Published by Edward H. Mitchell, San Francisco, California.)

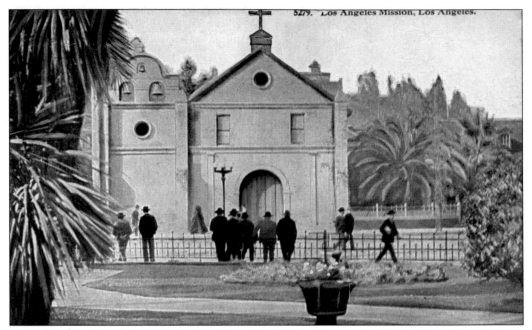

Believed to be the oldest parish church on the Pacific Coast, the Old Mission Church has a seating capacity of 500. In this view, a group of passersby are seen admiring the aged structure. (Published by the California Postcard Company, Los Angeles, California.)

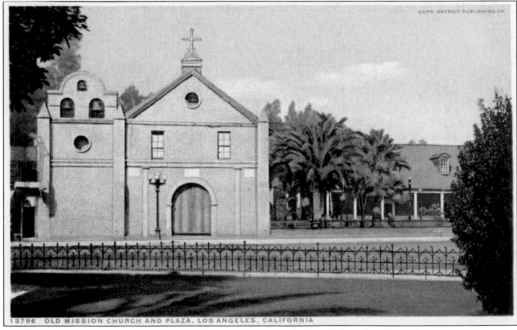

COPR. DETROIT PUBLISHING CO.

13796 OLD MISSION CHURCH AND PLAZA, LOS ANGELES, CALIFORNIA

The campanario with its three bells is just to the left of the church. The mission Native Americans who originally worked on the construction of the church were paid a coin known as a Spanish real each day, which amounted to about 12.5¢. (Published by the Detroit Publishing Company, Detroit, Michigan.)

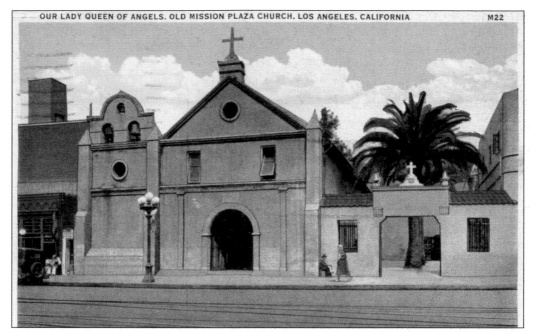

Seen on a card postmarked January 19, 1935, is the gated courtyard addition at right. Part of the written message on the reverse reads, "We are enjoying our vacation. Your dad wants me to go for a ride in a Zeppelin, one of the biggest in America. Shall I go? Mother." (Published by News Stand Distributors, Los Angeles, California.)

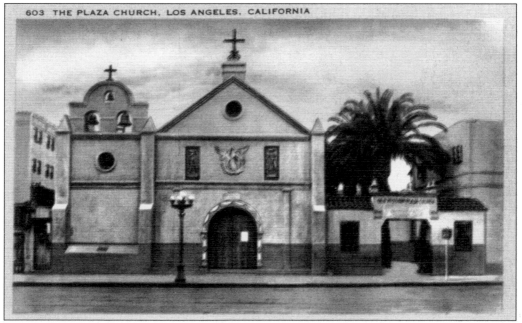

603 THE PLAZA CHURCH, LOS ANGELES. CALIFORNIA

The caption on the reverse of this postcard reads, "The Old Plaza Church, also known as 'Our Lady, Queen of the Angels,' is the oldest landmark in Los Angeles today. The first chapel was erected three years after the founding of the town in 1781. The present church was built under the supervision of Jose Chapman, California's first Yankee, and finished in 1822." (Published by the Longshaw Card Company, Los Angeles, California.)

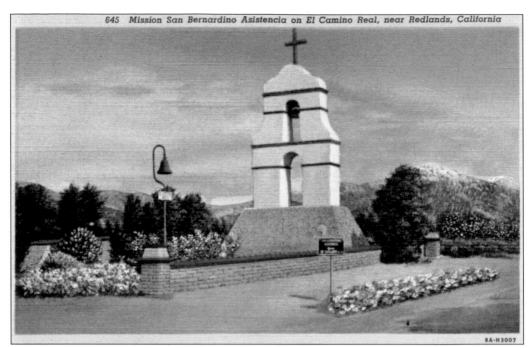

Here is the San Bernardino Asistencia, established in 1819, located on El Camino Real near Redlands, California. It was part of Mission San Gabriel's Rancho San Bernardino and had fallen into ruins until 1925 when the San Bernardino Historical and Landmark Society began its restoration. The bell tower, or campanario, shown in this postcard was modeled after one at the Pala Asistencia. (Published by the Western Publishing and Novelty Company, Los Angeles, California.)

The small chapel of the San Bernardino Asistencia was first built during the 1830s and was restored 100 years later. In 1960, it was dedicated as California Historical Landmark #42. (Published by Columbia Wholesale Supply, North Hollywood, California.)

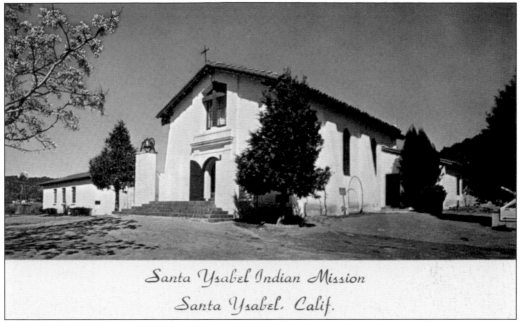

Santa Ysabel Indian Mission
Santa Ysabel. Calif.

The Santa Ysabel Asistencia was founded September 20, 1818, to serve as a sub-mission to San Diego de Alcalá. The cornerstone of the chapel pictured in this postcard was laid September 14, 1924. It was rebuilt on the site of the original asistencia. (Published by Amescolor, Escondido, California.)

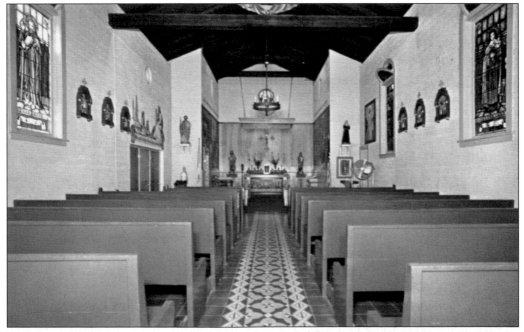

This image shows the interior of the chapel. An American traveler, John Russell Bartlett, noted in 1852 that Mission Santa Ysabel's church was without a roof and that only a few Native American huts remained on the site. Today this church still conducts regular masses on weekends and holidays. (Published by Amescolor, Escondido, California.)

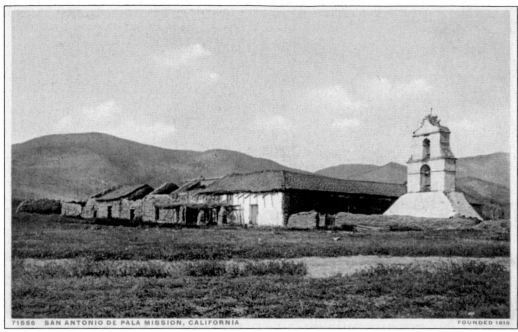

71556 SAN ANTONIO DE PALA MISSION, CALIFORNIA FOUNDED 1816

Founded on June 13, 1816, by Fr. Antonio Peyri, San Antonio de Pala is the only original asistencia to still serve the Pauma Indians, as it did when it began. (Published by the Detroit Publishing Company, Detroit, Michigan.)

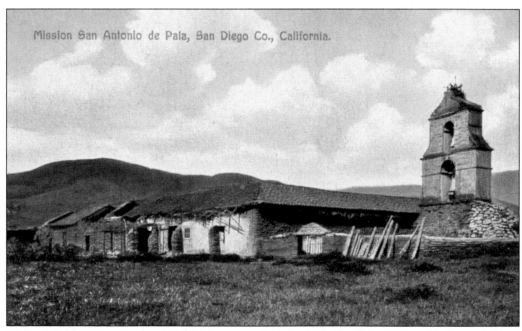

Mission San Antonio de Pala, San Diego Co., California.

The caption on the reverse side of this postcard reads, "Was built in 1816 and is located about 20 miles from San Luis Rey, to which it belonged. The Chapel is a narrow adobe structure 144 X 27 ft." (Published by the Newman Postcard Company, Los Angeles, California.)

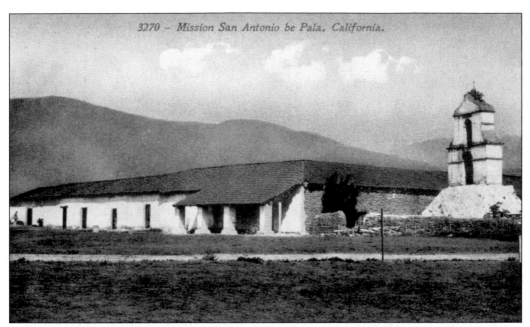

3270 – Mission San Antonio be Pala, California.

At its peak, this asistencia served about 1,000 Native Americans and actually rivaled San Luis Rey in importance. Note the typo of "be" instead of "de" in the title of this postcard. (Published by Edward H. Mitchell, San Francisco, California.)

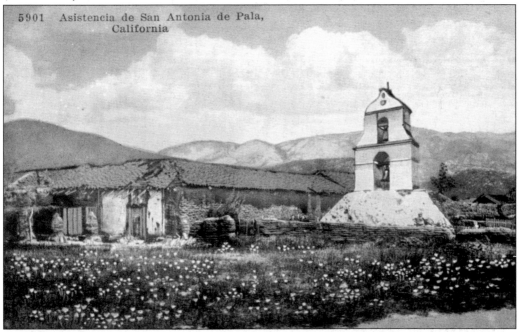

5901 Asistencia de San Antonia de Pala, California

The caption on the reverse of this postcard reads, "Asistencia de San Antonio de Pala, San Diego County, is about twenty miles from San Luis Rey, to which it was attached. The bell tower is the only distinguishing feature of the old establishment distant from the beaten roads of travel, and is the home of the remnants of the thousands of Native Americans who inhabited the surrounding county and reverence even yet the memories of the good fathers who labored for their welfare." (Published by the Pacific Novelty Company, San Francisco, California.)

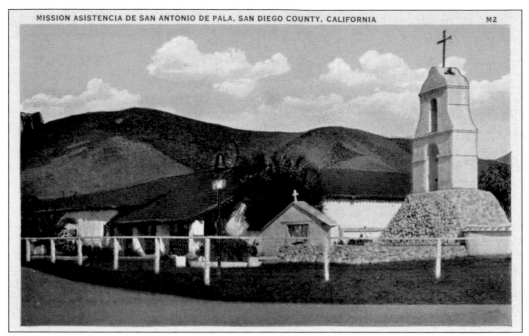

The asistencia was located in an ideal valley near abundant water. In fact, the name Pala is a Native American word meaning water. Even before Pala was established, farmers from San Luis Rey were raising corn on the fertile lands. (Published by News Stand Distributors, Los Angeles, California.)

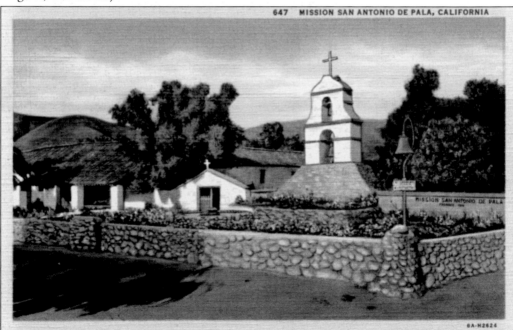

Located at the foot of the Polomar Mountains, Pala was severely damaged by a flood in January 1916. By April 1959, the mission was restored. Note the addition of the bell of El Camino Real in this image. (Published by the Western Publishing and Novelty Company, Los Angeles, California.)

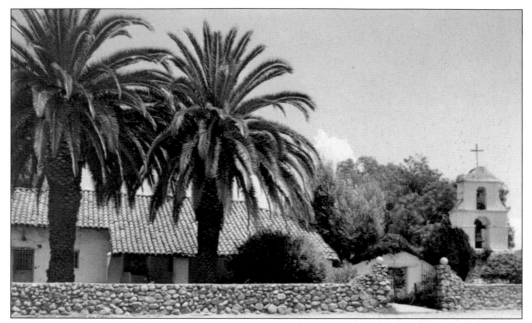

The caption on the reverse of this postcard reads, "Old Mission and Campanile of La Asistencia de San Antonio de Pala—Pala, California. Established in 1816 by the Franciscan Father Antonio Peyri. It is still an active church serving the needs of the people." (Published by Columbia Wholesale Supply, North Hollywood, California.)

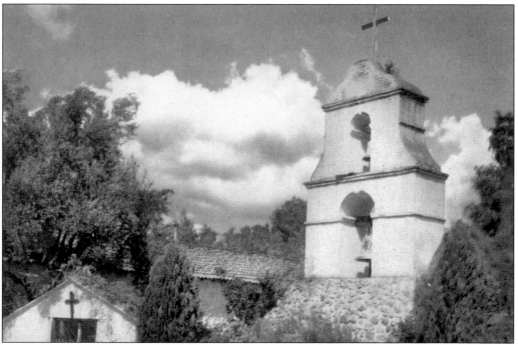

Pictured here is the bell tower, which is unique among all other missions in that a cactus grows on its top beside the cross. The caption on the reverse of this postcard reads, "Pala Mission in San Diego County is a charming little Native American mission located on the Pala Indian Reservation about 20 miles northeast of Oceanside." (Published by the Union Oil Company.)

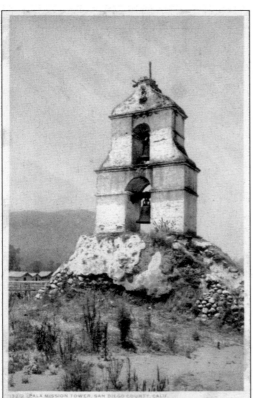

After the missions were secularized in 1835, Pala fell into a period of decay. When the plaster covering the adobe began to fall away and not be reapplied, the adobe bricks began to melt as the winter rains arrived. (Published by the Detroit Publishing Company, Detroit, Michigan.)

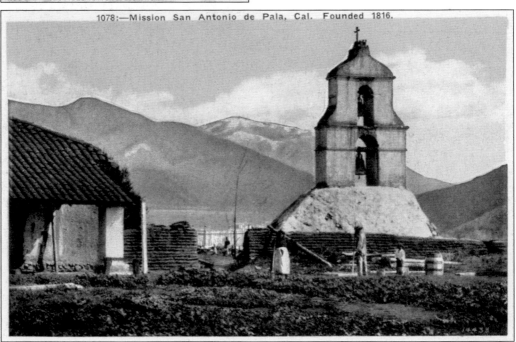

1078:—Mission San Antonio de Pala, Cal. Founded 1816.

Pictured here are the chapel at left and the campanario at right. In the distance, behind the campanario, is the mission cemetery. (Published by the M. Kashower Company, Los Angeles, California.)

The caption on the reverse side of this postcard reads, "The famed beauty and lovely campanario or belfry. One piece of architectural beauty at Pala, California has gained world renown. A feature unique in mission, if not Ecclesiastical Architecture of the world." (Published by Columbia Wholesale Supply, North Hollywood, California.)

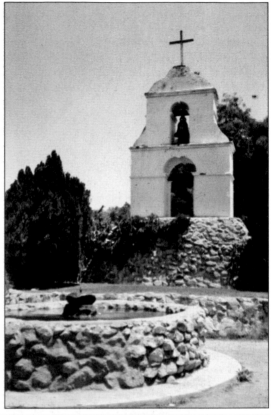

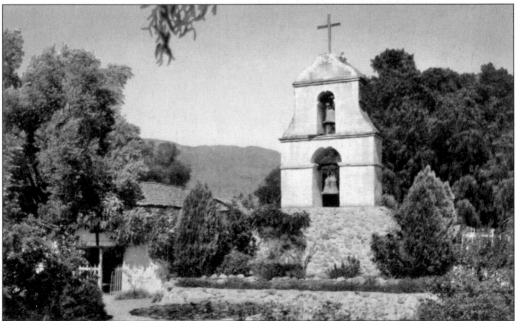

This postcard was postmarked September 24, 1957, and part of the message on the reverse reads, "This old mission is only a few miles away. Tom, Fay, Marion and I are all enjoying our reunion. Love, Madge." (Published by H. S. Crocker, Company, San Francisco, California.)

Pictured here is the Shrine of the Crucifixion located within the inner patio. Just beyond the shrine is one of the oldest pepper trees growing in California. (Published by Amescolor Publishers, Escondido, California.)

Depicted here is the old Luiseno cemetery where hundreds of Native Americans are buried. In the foreground are California poppies in full bloom. (Published by Walt Brown, Los Angeles, California.)

BIBLIOGRAPHY

Demarest, Donald. *The First Californian, The Story of Fray Junipero Serra.* New York, NY: Hawthorn Books, 1963.

Engelhardt, Fr. Zephyrin. *San Gabriel Mission and the Beginnings of Los Angeles.* Chicago, IL: Franciscan Herald Press, 1927.

Forbes, Mrs. A. S. C. *Mission Tales in the Days of the Dons.* Chicago, IL: A. C. McClurg and Company, 1909.

Hildrup, Jessie S. *The Missions of California and the Old Southwest.* Chicago, IL: A. C. McClurg and Company, 1920.

Hudson, William Henry. *The Famous Missions of California.* New York, NY: Dodge Publishing Company, 1901.

Johnson, Paul C. *The California Missions, A Pictorial History.* Menlo Park, CA: Sunset Books, 1964.

Lyngheim, Linda. *The Indians and the California Missions.* Chatsworth, CA: Langstry Publications, 1984.

Sanchez, Nellie Van de Grift. *Spanish and Indian Place Names of California.* San Francisco, CA: A. M. Robertson, 1914.

Wright, Ralph B. *California's Missions.* Los Angeles, CA: The Sterling Press, 1950.

Across America, People are Discovering Something Wonderful. *Their Heritage.*

Arcadia Publishing is the leading local history publisher in the United States. With more than 3,000 titles in print and hundreds of new titles released every year, Arcadia has extensive specialized experience chronicling the history of communities and celebrating America's hidden stories, bringing to life the people, places, and events from the past. To discover the history of other communities across the nation, please visit:

www.arcadiapublishing.com

Customized search tools allow you to find regional history books about the town where you grew up, the cities where your friends and family live, the town where your parents met, or even that retirement spot you've been dreaming about.